Enjoy,

From

André'L

Churchwell

2022

A Special Gift from
the Initiative for Race Research and Justice
at Vanderbilt University

RACE RESEARCH
AND JUSTICE

VANDERBILT.
Peabody College

Explore. Collaborate. Transform.

THE OTHER SIDE

A COLLECTION OF WRITINGS & DRAWINGS

BY

ANDRÉ L. CHURCHWELL, M.D.

THE OTHER SIDE

A COLLECTION OF WRITINGS & DRAWINGS

BY
ANDRÉ L. CHURCHWELL, M.D.

<u>DEDICATION</u>

This book is dedicated to the five most important people in my life: My Mom, Dad, my lovely wife, Doreatha Henderson Churchwell, and my kids, Crystal and Dré.

And special thanks to Barry Noland for his tireless efforts to help me put this together.

February 26, 2018

PREFACE

We are in the early years of the 21st century, when writers of all genres are striving to make sense of these frenetic times and offer us some clarity to its overwhelming melancholy and negativism.

Multiple authors encourage us to seek more self-reflection, self-recreation, self- awareness, and new insights. How can one achieve all these goals, do your job, and tend to your life and family?

Well, I have chosen to create time in my life to think, read, draw, and connect to my true friends and myself. Connecting your intellectual resources to new and different ideas and tasks leads to a vivifying effect on your mental skills.

Lives of unique individuals like Winston Churchill and Leonardo Da Vinci challenge us to find our creative place and time. In doing so, these moments and activities enrich your life and make you better at your day job. This small book will offer you a window into my fervent attempts at odd hours to create and to think big and small thoughts.

As you read, you will see me challenge myself in multiple areas: poetry, prose, drawing, sartorial matters, and new self-insights. I will offer some introductory thoughts for each section.

I would like to thank Maria De Varenne of the Nashville Tennessean, Christina Lanzisera, managing editor of the Texas Heart Institute Journal, and the owners of FLIP, the superb men's store in Nashville, Tennessee, for allowing me to re- produce my writings that were posted on their media sites. Thanks to Alpha Omega Alpha Honor Medical School Fraternity editors to the journal, The Pharos, for permission to use the letter "Daily Devotion.
I hope you will find some joy in these meandering thoughts.

CONTENTS

POETRY 11

PROSE 23

THE TENNESSEAN "TENNESSEE VOICES" 47

SATORIAL MATTERS 65

DRAWINGS 95

POETRY

POETRY

Not being a "professional poet," I cannot say why I was moved to write these pieces. There is something to be said about occasionally listening to your muse.

AGING or Twisting Your Life Away

Life's molecules twist and undulate
like oyster pearls on a string.

Breath and life are
suffocated by another of God's
twisting, delicious,
and asphyxiating creations—sausage links.

We wish for Winston Churchill's genetic resilience.
To scoff at death while ingesting a copious diet
 of sausage, eggs and vino.

Like Sinatra, he smiled
and after over 8 decades of life
offered one more toast to
immortality.

DNA cracks under the unrepairable influences
 of wear and time that leads
us all to a common quiet place.

So, raise your glass again and
smile for joy and life
to be endured before
apoptosis has its way.

CHITTERLIN'S or What's in a Name?

Cold day in January.

Harvest from the butcher's annual surgical evisceration.

Anatomy serpentine, elongated and quite still.

Liberated from intestinal peristaltic purgatory to culinary eccentricity!

Now boiling and steaming in an aged iron kitchen pot.

Nature's noxious scent and rising vapors fill the room.

Half of the human respiratory cycle is partially suppressed.

Finally, the result laid bare on the supper table.

There is always less than you thought.

Folks gather around.

Those that do and those that don't.
Post repast, now supine, and all senses satisfied like post-coital rapture.
As endorphins recede, gastronomic rumblings begin.

One last thought . . .

Pepto Bismol?

GAUDEAMUS IGITUR, NO. II ("Therefore, Let Us Rejoice")

*Homage to John H. Stone, MD—Poet, Friend, Humanist, and Cardiologist—
and John's Poem "Gaudeamus Igitur: A Valedictory Address." (1982)*

This poem is read each year at the parents' dinner for our graduating minority
students.

Let us rejoice in this celebration.
Let us rejoice in this end of a
Beginning and the beginning to a new end.

Let us rejoice that the days of
Healing can now begin.

For in healing, our lives are made
More meaningful.

That to heal, we must be constantly
In the moment, human and
Doubly humane.

For in healing, we are connected to
Hippocrates and Pasteur and Osler and Drew.

For we who are gathered here
Must ease suffering
And know and care in equal amounts.

We must know pathos, loss and joy, fully;
For they are always near.

That from our connectedness, we
will know
When death has entered the room.

For we understand that no one
Dies of a spider angioma and vigilance
Will be required to recognize
The tracks in the snow, of the Silent, MI.

That God's rhythm, the ECG,

Can have peaked T waves
That must be feared, recognized, and treated.

That we must know diabetes and
Its acidosis and coma and all of its
Deadly ways.

For we must know that hard work and
Disciplined, reassured, self-regulated thoughts and actions
are part of doctoring.

We must know of Kussmaul's Sign,
The angle of Louis (Armstrong),
And Heberden's Nodes.

That Vanderbilt, this place of
Manicured green lawns, gathered friends,
And enduring lessons, stands eternal
And, for you, will remain a repository of knowledge,
People and memories.

For you will come to understand the virtue
Of giving a piece of yourself to every
Patient only deepens your healing value and effect.

For you will sometimes not find
McBurney's Point or Virchow's Sentinel Node.

That you will find solace in the smile of a Child
 and a letter from a patient.

That DNA and science have a magnificence,
And you will be compelled by them to know more
Because you care; and you will push
Your limits to see more, feel more,
And in all of this you will become a better doctor.

That you will see frailty and seek To be wise and compassionate.

That there will be times you will know what you don't know

And be obliged
To know.

For integrity is priceless and, oftentimes, humor
will be your greatest medicine.

That you will cross the "interpersonal
chasm" between you and your patient with
life stories and expressions of your
own vulnerability.

For we will not only know "The Sounds
of Silence" but also, the sounds Of Borborygmi,
Of Eructation, Of Peristalsis and
Of Hamman's Crunch.

For we will know Amiodarone, That witch's brew, can cease the
Quivering of the fibrillating heart.

Finally, let us rejoice in the
Knowledge of cavernous sinuses,
spots of Roth, and edema that pits.
Let us wade through fluid in the
Cul-de-sac, feel the waterhammer pulses of
Corrigan, and know of Quinke's Blanching Pulse.
And in knowing these "pearls,"
We may thankfully rejoice, that I am,
Finally, at The End.

References:
Stone, John H. "Gaudeamus Igitur." Renaming the Streets. Baton Rouge:
Louisiana State Univ. Press, 1985.

TO FLY TO ROME or Thoughts while Sitting on the Runway at O'Hare

Like Icarus, we yearn to fly as we sit embedded in the breast of this cavernous metal bird.

Masses configured in rows and aisles, all minds with one-winged thought; defy Newton and reach Rome in less than a day.

All hopes are similarly focused on that one single thought.

Unfortunately, man's failings and serendipity meet again, briefly confining our steel bird to terra firma.

Maybe an early dinner replete with vino will mollify my cultivated impatience.

Sing a toast to buoyant air, Archimedes' Principle, Leonardo da Vinci, and a timely and safe trans-Atlantic flight!

<u>YOU ARE THE LAST MAN OF THE 20th CENTURY – WHO OR WHEN . . .</u>

You know who Emily Post is.

You stand at the dining room table
when your elders or wife arrive.

You remember the day Martin Luther King, Jr. was assassinated.

Wearing tee shirts, short-shorts, and tennis
shoes are relegated to casual dress.
Not for evening dinner dress with
your elegantly-attired wife in her new cocktail dress.

You know that Jack Paar was the wittiest man ever on evening television.

Opening the car door for your wife and
Mother is reflexively performed.

You don't begin eating your meal until
your guests are seated and their
food in place.

Knows semi-formal dress is black tie and
formal dress is white tie.

You remember the day Nixon left the White House on
Marine One.

You have seen all twenty years of
Gunsmoke.

"Yes ma'am" and "Yes sir," fill your
daily salutations.

November 22, 1963 is permanently etched in memory.

You know the TV show "The Naked City" was not about naked people.

Recognizes the sartorial value of the mid-Atlantic
trouser break on his shoes and

never violates this <u>golden</u> rule.

Understands the social imperative of
lowering your voice when dining <u>out</u>.

Knows and understands the greatness
of Churchill, Martin Luther King, Sr. and Jr.,
FDR, Gandhi, Eleanor
Roosevelt, and Dorothy Height.

Understands the immortal importance of
the paper press and holding a palpable book.

Remembers where he was and what he was doing on 9/11.

Knows that Johnny Weismuller was the
"Real" Tarzan.

Understands that Armegeddon and
the Atomic Bomb are synonymous
and unacceptable solutions for
human disagreements.

Knows the most flattering
thing a man can wear is a blue suit,
a white spread collar shirt,
silver satin tie, light grey houndstooth
socks, and polished black cap toe shoes.

Recognizes that Louis Armstrong was the greatest and most influential
American musician of the 20th century.

Remembers siblings birthdays
and his parent's anniversary.

Understands the solemnity of Veteran's Day,
D-Day, and . . . "The Day That will
Live in Infamy."

Recognizes that it is the small acts

of kindness and simple courtesies that
sustain a civilization and when
neglected for overt narcissism, the
end of our days will soon be upon us.

Please note, these musings are those of an aging man born in the last half of
the 20th Century and whose values, beliefs, and social mores were forged in
those intemperate and life-shaping times.

He believes The Rock of Gibraltar, monumental in size, can serve as a
metaphor for a rules- governed society. Civilized behavior and rules are
viewed as pieces of this magnificent structure and when "erosion" occurs,
due to unmitigated boorish or immoral behavior, the giant rock is lessened.
Let us remember that many important, apparently immutable structures can
lose parts and dissolve, never to be fully reconstituted.

As we begin our extended journey into the 21st Century, let us stay
connected to those past thoughts and actions, that continue to add meaning
to our lives and sustain a Civilized Society.

PROSE

PROSE

My writings are stimulated by life experiences that emotionally move me. This led, for example, to the piece on my first visit to Europe.

The essays in this section are a mixture of writings prompted by lectures, serious life events, and some, stimulated by serendipity and "spontaneous imagination."

My father was the first African-American to write for a southern newspaper. He was such a notable and thoughtful writer that he won many journalism awards. He was inducted into multiple journalism societies, and posthumously was awarded the Helen Thomas Lifetime Achievement Award by the Society of Professional Journalists. His night job was trying to offer his children a view of an ethically modelled life. He also challenged us to be better writers. He served as the "editor" of my writing for years. As I assiduously worked to improve my writing under his watchful gaze, I was subject to the acute creative edits of his red pen. It was only when I reached the age of forty-two, that he informed me that my writing did not require his edits. In this regard, the Nashville Tennessean, our local daily paper, has published my recent thought pieces and has allowed me to share them with you!

It will be quiet evident that I value the valedictory speech of Judge Elbert Tuttle. My mentor, J. Willis Hurst, felt this was the signal piece on what defined the professional man (and woman). I often use it in talks to young audiences. Repetition at times can be a good thing!

FRED ASTAIRE SPEECH: A LIFE OF PANACHE IN SUEDE SHOES!
October 3, 2013

No less experts than Mikhail Baryshnikov, Rudolph Nureyev, and George Balanchine ranked him as The American dancer of The American Century. He was born at the end of the Victorian Era and the start of the Edwardian. The year was 1899, an epochal year—the start of the 20th century. His birth year was crowded with many babies "pushing" their way into the new century: Eugene Ormandy, Noel Coward, Kay Francis, Al Capone, Cornelius Vanderbilt Whitney, Gloria Swanson, August Busch, Irving Thalberg, Edward Kennedy Ellington, Charles Laughton, George Cukor, E.B. White, Allen Tate, Pat O'Brien, Ernest Hemingway, Harold Arlen, Alfred Hitchcock, Humphrey Bogart, Jorges Luis Borges, Charles Boyer, Hogie Carmichael, and Pie Traynor to name a few. What a group!

America and its sons and daughters shaped the world during the 20th century—in so many disciplines. Some with equal or greater talent than our subject include:

- Greatest American musician—Louis Armstrong
- Greatest Jazz Piano Players—Art Tatum, Bill Evans, Oscar Peterson, Nat Cole and Errol Garner.
- Greatest Popular Singers:
 - Bing Crosby defined romantic singing and how to use the microphone.
 - Frank and Ella taught us how to swing!
- Greatest Popular Music Composers—Berlin, Gershwin, Ellington, Porter, Arlen and Mercer
- Greatest All-around Talents—Al Jolson and Sammy Davis, Jr.

But his influence on theater, film, and dance is without question and defined how you dance on the stage and screen. Every popular music composer of the 20th century yearned to write music for his theatrical musicals and films. He was not the typical romantic star by height and looks, but no one defined romantic dance or sexuality in dance better than Fred Astaire.

Astaire was born May 10, 1899, to Frederic Austerlitz and Ann Gelius—both of Austrian origin. It's a matter of fact that Fred's father left Austria due to an entanglement with his brother and the Austrian Army; he refused to salute his older brother Ernest and was imprisoned.

Upon arriving in America, Fred's father was employed by an Omaha brewery and fashioned himself as a local performer. With marriage to the younger Ann Gelius, Fred Astaire was born three years after his sister Adele. Adele revealed advanced performing skills at an early age, leading her parents to send her to dance school; Fred was sent too—mostly to keep them together. There was a sense that Adele had "the goods"—charm, quick wit, and proven performing skills—in singing and dancing. Mr. and Mrs. Astaire, noting this early ability, thought their children would have greater success as performers

by leaving the Midwest rather than settling for a mundane existence in this distant American outpost. Through funds saved by their father's employment, the children, with their mother, began the long journey from travelling vaudeville performers to the big-time of Broadway and the Ziegfield productions. At times, because of Adele's taller height, she would be the male lead and Fred the female. Their early performances were reworks of other successful vaudeville acts or abbreviated song and dance numbers with Adele being the star performer and Freddie her willing second banana and supporter or straight man or woman, based on the act.

Their schooling was handled by Mrs. Astaire on the train rides or backstage between shows on benches and chairs. As they progressed into their teens, there were periods of downtime when they couldn't get bookings or were between jobs and they would attend school. The kids had a moderate amount of success in the lower-rung vaudeville circuit across the country. They traveled coast to coast and from this transcontinental activity became highly educated about life on the road in early 20th century America. Along the way, their parents employed multiple teachers of acting, dance, and singing. The dance of the day was so-called "ballroom dancing" or a version of the two-step—the acknowledged dancing stars of that period, Vernon and Irene Castle. Tap dance as we now know it was a young evolving art form—its beginnings were from the Irish jig and buck dancing—the African-American dance modified from African tribal dancing. For historical correctness, at some point, this more casual individual style of dance split off into "clogging," a southern American popularized by variant, and true tap dancing—dancing on your toes and slapping your toes and heels. Clogging generally involves using the entire foot on the "slap." Astaire, the continual thinker and "moaner," as his sister called him, was constantly looking for ways to advance their art. Tap dance was clearly something he saw value in—not ballet—which he disliked. He observed Bill "Bojangles" Robinson when they played the same city and began to arrange for lessons. He thought that John Bubbles of the dance team, Buck and Bubbles, was more graceful and had more intricate steps. His relationship with these black teachers extended over decades. Diana Vreeland recounted a story in the 1920's of her accompanying Fred and Adele after a Broadway opening to Harlem for a tap lesson with Bill Robinson.

In reviewing this part of Astaire's life, it is apparent that in young adulthood he took over choreographing their dances and developed solo performances utilizing his unique style of tap. Astaire, like John Bubbles, and unlike Bill Robinson and his closest film competitor, Gene Kelly, danced with his entire body. Critics described him as if he were a "dancing India Rubber Man" or as if his bone marrow was filled with helium. The unique dancing relationship forged with years of work between he and Adele, led many theater critics to feel that if Adele left the team, he would flop. Well, in fact, she did leave him in 1931 to marry Lord Cavendish—the son of the Duke of Devonshire. There was a little problem accepting her within English royalty because of the Astaires' Jewish heritage, and because she was a commoner. These issues were overcome. Unfortunately for Dellie (family name), Lord Cavendish was a drunkard and died in young adulthood.

Fred was called "Moaning Minnie"—Dellie's nickname for him due to the worrying and fretsome nature he manifested during rehearsals. This worrying nature lead to his perfectionist tendencies and his unmatched work ethic—4-6 weeks of practice on the dance routines before a stage show or film musical! In 1931, Fred starred opposite Claire Luce on the Broadway stage in "The Gay Divorce" and, in spite of some negative reviews that described him as "appearing to be constantly looking to the wings for his sister to appear," the show ran over 200 performances and, as many of his stage shows did, had a long run in the West End in London.

Unfortunately, there is no record of the film test that Fred and Adele shot in the 1920's at a New York film studio. Both this and Fred's later test for 20th Century Fox for Darryl Zannuck are lost. It was in the later film test that the asinine infamous 1931 line was uttered by the test viewers: "Can't Sing. Can't Act. Balding. Can Dance a Little." David O. Selznick reviewed the test and realized his potential and, with agent Leland Hayward, offered Fred a contract with RKO films.

In his social life, Fred Astaire was a notable bon vivant and squired many rich socialites. After many opportunities, he fell in love with the divorced New York socialite, Phyllis Potter, and married her in 1932 before moving to Hollywood.

At RKO, he was reunited with a former girlfriend, Ginger Rogers (b. 1911), who we know, at a minimum, exchanged some French kisses with Fred. They met while Astaire was in New York City and frequently dated. Ginger's contract with Warner Brothers and a move to Los Angeles concluded their relationship at that time.

Needless to say, Astaire's usual concern about success went by the wayside when he and Ginger caught fire in supporting roles in the 1932 movie "Flying Down to Rio." Fred and Ginger danced "The Carioca" and the country went wild. Kate Hepburn said that it was partly because "He gave her class and she gave him sex." Fred, years later, when confronted with the Hepburn analysis on the Dick Cavett Show in the late 1960's, stated that she was "full of s...t!"

After the initial success of "Flying Down to Rio" and, subsequently, nearly all of the Astaire- Rogers' films, Fred was determined to not play second banana again or be tied to one partner— like in the case of his sister. Thus, with the slight decline of their movies in the late 1930's and Ginger's wish to move on to more "serious acting roles," they split after 1939 and each went their separate ways. Fred then embarked on a seemingly constant search for the perfect dance partner—likely finding it at MGM with Vera-Ellen and Cyd Charisse—two accomplished professionally-trained dancers. Fred and Ginger performed one last time in 1949, in MGM's, "The Barkley's of Broadway"—a moderate box office success.

What about Astaire's films and how they are now critically viewed? The American Film Institute, Martin Scorsese, and many other experts of film are constantly creating a rank list of the top

movies of all-time. Certainly, Orson Welles' masterpiece, "Citizen Kane," and "Casablanca" are often at the top of the lists; but somewhere in the top 20, you will invariably find "Top Hat" (1935) and "The Bandwagon" (1953). In some of the lists, you will often also see "Swing Time" (1936)—George Stevens' marvelous Astaire-Rogers film. Though the films were formulaic, it was art deco magic created by director Mark Sandrich and Astaire's genius that made them signal events for the movie viewing public. The Astaire and Rogers films were tonic for the terrible times that The Depression caused in this country.

Over the years, Fred cultivated a number of other interests including an exhaustive clothing collection—stimulated by his relationships with Douglas Fairbanks, Sr. and the Duke of Windsor. Both men's taste in clothes aligned with his. Astaire created the "Mid-Atlantic Look" or the "Americanization" of the "Savile Row Look." The "mid-Atlantic" look meant his choice of clothes and the manner in which he wore them, put him somewhere "between America and London"— in the middle of the Atlantic! He helped stimulate the concept of creating your own style of dress—flannel trousers, Brooks Brothers button-down #346, suede shoes, loud socks, and softly tailored tweed jackets and flannel suits—both single-breasted and double-breasted.

His serious clothes were made by the Saville Row firm, Anderson & Sheppard (1907), who excelled in soft tailoring—no extended shoulders and softer canvas construction—the jackets wore like cardigans. His more casual-American dress was played off the stiff aristocrats he partnered with or opposed in film. Astaire, more than any American, influenced modern dress and modern designers from Ralph Lauren to Luciano Barbera. Also a related feature of the actors of Astaire's time was their realization of the importance of clothes in creating an image. They viewed developing a personal style and wardrobe imperative to stardom and success. No costume designer for these guys, short of a historical film!

Another passion was horses and horse-racing. This was cultivated by his association with rich English aristocrats and American corporate royalty— John Whitney, Alfred Vanderbilt, Jr.—all of whom had horse farms in Aiken, S.C. During his first retirement from work in 1946 (after the movie "Blue Skies"), he spent most of his time on his ranch outside Hollywood working with his horses. Triplicate, his special race horse, won the Santa Anita Derby and a number of races.

By this time in this career, he was quite wealthy. His agent, Leland Hayward, had secured a special deal in his contract with RKO that gave him 10% of the profits of the Fred and Ginger films.

He finished his last musical in 1957, "Silk Stockings," and due to an unusual inherited sense of agility, balance and rhythm that seemed superhuman, he was able to remain active until he passed away from pneumonia in 1987. Many athletes are in awe of his agility and physical abilities. He played golf with the pros and had eye and hand coordination that was unique and seemingly unaffected by age. He could kick a nail on the floor across the room and send it into the wall. He could toss his porkpie hat on one take

across the room and land it on the antlers of a stuffed moose head hanging on the wall!

America has had many great tap dancers—Bill Robinson, John Bubbles, Donald O'Connor, the Nicholas Brothers, Gene Kelly, etc.—but only one Fred Astaire. He set a standard that is likely never to be reached or attained. George Stevens, at Astaire's 1981 American Film Institute tribute, closed the tribute with a quote from Milton's "Paradise Lost":
"Grace was in all his steps, Heaven in his eye,
And in every gesture, dignity and love."

We will be in awe of and marveling at Fred Astaire's genius for decades to come.

References:

- Boyer, G. Bruce. "Fred Astaire Style," New York: Assouline Publishing, 2005.
- Astaire, Fred. "Steps in Time," New York: Harper and Row, 1959
- Billman, Larry. "Fred Astaire: A Bio-Bibliography," Westport, CT: Greenwood Press, 1997.
- Giles, Sarah. "Fred Astaire: His Friends Talk," New York: Doubleday & Company, 1977.

TRIBUTE READ AT MEMORIAL SERVICE OF LEVI WATKINS, JR., M.D.
April 21, 2015

(Dr. Watkins was the first African-American student admitted to Vanderbilt University School of Medicine)

A friend, mentor, biomedical researcher, preacher, confidant, role model, civil rights advocate, and teacher. These are just a few of the adjectives I can use to describe Levi Watkins, Jr. He was so much more than what could be described by a single or a group of descriptors. As reflected in his life of service, he treated ALL he encountered with equanimity and respect— from the janitor at Johns Hopkins Hospital to the Chancellor of Vanderbilt University.

I met him in the summer of 1979, but had first heard of him in 1966, when he was the "big man on campus" and the outstanding graduate of my mom's alma mater, Tennessee State University. He appeared to this thirteen year-old, as smart as Einstein and as cool as any Rat Pack member. As if patterned after Sinatra or Miles Davis, he was the acknowledged Mr. Esquire, the "king of cool" on the TSU campus, and voted Mr. Brain—the smartest graduate.

In 1979, as I pondered a career in cardiovascular medicine, I was referred to him for guidance by a number of mentors at my medical school. At the time, he was at Johns Hopkins, just beginning his long run as a leading cardiac surgeon. He was larger than life to this senior medical student; and his advice on studied preparation and on the virtue of humility still resonate with me now.

I reconnected with him in 1986 at the Robert Wood Johnson Foundation during the application process for a Harold Amos Minority Faculty Development Award; from this career-altering experience, we became life-long friends.

Since his passing, I have received email after email of tributes, sent by friends and colleagues of this great man.

His was a purposeful life that mattered; and Tennessee State University, Vanderbilt University, Vanderbilt University Medical School, Johns Hopkins Medical School, and scores of minority students around this great country have benefitted from his wise counsel, friendship, buoyant optimism, and humor. The noble ideas expressed by iconic civil rights judge, Elbert Tuttle, in his valedictory address (1957) to the Emory University graduating class, best describes, for me, Levi's life of service:

> "Do not be a miser, hoarding your talents and abilities and knowledge, either among yourselves or in your dealings with your clients (patients). Rather, be reckless and spendthrift, pouring out your talent to all to whom it can be of service! Throw it away,

waste it, and in the spending, it will be increased. Do not keep a watchful eye lest you slip, and give away a little bit of what you might have sold. Do not censor your thoughts to gain a wide audience. Like love, talent is only useful in its expenditure, and it is never exhausted. Certain it is that man must eat; so set what price you must on your service. But never confuse the performance, which is great, with the compensation, be it money, power, or fame, which is trivial. . . . The richness of life lies in the performance which is above and beyond the call to duty."

He now stands shoulder to shoulder with Drew, Osler, Stead, and other giants who went before him: all men who changed medicine and its culture.

He will be irreplaceable.

References:
Elbert Parr Tuttle, "Heroism in War and Peace", The Emory University Quarterly. 1957; 13:129-30.

I am honored to be asked to come to Montgomery Bell Academy and talk about Martin Luther King, Jr. I am sure, many of you have studied American and European history. From those exercises, you are aware that there are a number of people who have left us notable quotes and speeches—consider Dorothy Parker, Confucius, Satchel Paige (my favorite), Winston Churchill, John F. Kennedy, Martin Luther King, Jr., and others. During MLK's sermon, "Our God is Marching On"—March 25, 1965—in response to how long must the African-American endure the tortured life of racism in America, MLK said: "How long? Not long, because the arc of the Moral Universe is long, but it bends towards justice."

I am old enough to remember the times of travail and the Jim Crow incidents that were all too common in Nashville in the 1960s. . . . For us to go forward and learn from such decadent times, it takes men like MLK and Nelson Mandela to challenge us to reach for the best in the human experience and resist the natural tendency for retribution that many might seek in response to racist acts. King often said, "Love is the only force capable of transforming an enemy into a friend." He dared us to remember: "The ultimate measure of a man is not where he stands in moments of comfort and convenience, but where he stands at times of challenge and controversy." He further challenged us to remember darkness cannot drive out darkness: only Light can do that. Hate cannot drive out hate: only Love can do that.

The message of love and its healthy effect on human interactions has manifest itself in what Diversity has done to make our institutions better. New York Times columnist, Tom Friedman recently informed us that "The World is Flat," and I would add, very multi-colored. International corporations and institutions of higher learning—dare I say, like Vanderbilt and MBA—have recognized that board rooms don't look like they did in the 1960s—all white and men—but with more women and a multi-racial/ethnic composition. All U.S. 4th year medical students fill out a questionnaire at graduation that asks about their experiences. Vanderbilt students annually state that diversity enhanced their learning experiences in ways they never knew it could. Having diverse class gets top marks each year. Students learn so much from a diverse class—allowing students of different faiths, races and ethnicities to recognize their shared beliefs and work out their differences. Dr. King said, "Integration is an opportunity to participate in the beauty of diversity."

I thank you for the opportunity to meet with you and share experiences and lessons from my life. Martin Luther King certainly believed that Life is a continuous work in progress, requiring many mentors with different skillsets. I have been fortunate to have many mentors who have shaped me as a man and physician. Along with my father, one such man was Dr. J. Willis Hurst—the Chair of Medicine at Emory School of Medicine for nearly 35 years. He lived a modelled life and strove to share with us the best of what he thought and learned. One such notable example is the definitive essay on what

defines a Professional Man written by the Georgia civil rights Judge Elbert Tuttle. I will read chosen pieces from the text delivered as the valedictory address at the Emory University Graduation Ceremony in June, 1957. I might add that Judge Tuttle's moral convictions mirrored that of MLK, Jr.'s.

The professional man is in essence one who provides service. But the service he renders is something more than that of the laborer, even the skilled laborer. It is a service that wells up from the entire complex of his personality. True, some specialized and highly developed techniques may be included, but their mode of expression is given its deepest meaning by the personality of the practitioner. In a very real sense his professional service cannot be separate from his personal being. He has no goods to sell, no land to till. His only asset is himself. It turns out that there is no right price for service, for what is a share of a man worth? If he does not contain the quality of integrity, he is worthless. If he does, he is priceless. The value is either nothing or it is infinite. So do not try to set a price on yourselves. Do not measure out your professional services on an apothecaries' scale and say, "Only this for so much." Do not debase yourselves by equating your souls to what they will bring in the market. Do not be a miser, hoarding your talents and abilities and knowledge, either among yourselves or in your dealings with your clients . . . Rather be reckless and spendthrift, pouring out your talent to all to whom it can be of service! Throw it away, waste it, and in the spending it will be increased. Do not keep a watchful eye lest you slip, and give away a little bit of what you might have sold. Do not censor your thoughts to gain a wide audience. Like love, talent is only useful in its expenditure, and it is never exhausted. Certain it is that man must eat; so set what price you must on your service. But never confuse the performance, which is great, with the compensation, be it money, power, or fame, which is trivial.

Now, as you return to your classes this morning, recall Judge Tuttle's message as well as a statement that serves as a summation that Dr. King could have written: "The function of education is to teach one to think intensively and to think critically. Intelligence plus character—that is the goal of true education." Remember, King's messages were both provocative and quieting at the same time. Let us leave with the resolve to grow . . . and learn . . . and strive to follow his unwavering moral compass.

References:
Elbert Parr Tuttle, "Heroism in War and Peace", The Emory University Quarterly. 1957; 13:129-30.

"FAITH AND THE SUPER BOWL" (Seay-Hubbard United Methodist Church)
March 16, 2012

Thankfully for the people gathered here, this is more of a story than a sermon. I am sure there are lots of questions out there—such as "What can 'Faith and the Super Bowl' have in common?" There is the possibility that I am referring to having faith in your favorite team to win the Super Bowl. No, that is not the story or the message.

There could be the faith or hope that your minister is not planning a late Sunday evening service or Bible study on the day of the Super Bowl. Well, mercifully, it is none of these choices.

This is about how a doctor in Nashville, Tennessee, can have a role in this year's Super Bowl and how faith and the Lord move into our lives at key times; and how two seemingly disconnected stories are linked.

To understand why my title is appropriate for today, we have to travel in our own private time machine: We will arrive in Nashville—specifically East Nashville—in the mid- and late-1960s.

At that time, in home of Robert and Mary Churchwell, there lived 5 kids—four boys and one lucky girl—lucky, because she had three adoring and handsome brothers to help her along the way. Most of what I'm saying remains true today! My sister, Marisa, will vouch for me! On Sundays after church and after Mom's spectacular, not-to-be-missed Sunday dinner (which included the heavenly cholesterol cuisine of past and present) the boys and Dad settled down to watch The NFL Today and their favorite team—the Baltimore Colts.

Why the Colts? Other team's games were shown on Sunday—the Atlanta Falcons, the Minnesota Vikings and the dreaded Lombardi-coached Green Bay Packers (because we are in church, I will not mention the other more colorful adjectives we used at the time to describe the Packers). Back to the Colts . . . The blue-collar appeal of the Colts resonated in a house where hard work, commitment to an end and a no-nonsense father and mother set the direction of their kids' lives. We knew about the Colt's story and their dependence on the pinpoint passes of Johnny Unitas and the precise routs of Raymond Berry. We had read Sports Illustrated's articles of the long, arduous hours Unitas and Berry put into making their combination—the best in the history of the NFL. We understood that Raymond Berry wore glasses and had one leg shorter than the other and of the modifications he had to make to compensate for these infirmities. Early painful contact lenses corrected his vision. Hours of conditioning (carrying concrete blocks tied to his waist behind him) to compensate for the lack of blazing speed. PLAYING AN ENTIRE GAME BY HIMSELF in the Texas Summer heat to build endurance and mental toughness! When "Johnny U" tired of throwing passes to Raymond, he would have his beloved wife Sally throw him passes. He said hers were harder to catch—not being tight spirals. While this was going on in

Raymond's career, there was a bookish kid—André Churchwell— who had certain physical limitations and saw a kindred spirit in Raymond Berry to idolize and copy on Saturday and Sunday street football games. Young André would run route after route trying to channel Raymond Berry's precision in his street football routes. You see, I had determined with Dad's help that I had a much better chance of getting into Vanderbilt for college and Harvard for medical school than making it to the NFL. Still I was bent on being the best East Nashville street ball split end there ever was. We played out our dreams by playing "touch football" on North 9th street. The field was the new asphalt surface of North 9th Street in front of our house. The goal posts were two telephone poles; and I guess that the field was approximately 50 yards long. I can say that between my brothers and me, we kept the emergency room surgeons at the old East Nashville Miller's Clinic in business from our tumbles in the street or crashes into parked cars. We had to have heavenly oversight to not have been seriously injured (he does focus on helping "foolish souls"). Playing the kids of Silvadene Street in East Stadium—on a real football field with real goal posts—was our "Super Bowl." And of course, Dad's watchful and discerning eye was not there. At the stadium, we played TACKLE FOOTBALL . . . followed by more trips to Miller's Clinic. For most games back then, you'd have to picture me wearing a T-shirt with a magic marker-inscribed number "82" on my back—the number of Raymond Berry, my hero.

Fast-forward in time: I get into Vanderbilt, Harvard Medical School and to my training. At roughly the same time, Raymond finishes a legendary pro career as the greatest receiver in the history of pro football with a pile of records—some of which still stand. He coaches—passing on his training and love of the game. He becomes the coach of the Super Bowl-bound 1985 New England Patriots. I need to interject an important connection here. He had to pass a physical to coach. He was seen at the Massachusetts General Hospital (affiliated with Harvard Medical School) by two soon-to-be mentors of mine, Dolph Hutter and the legendary cardiologist, Roman DeSanctis. I met Dr. DeSanctis as a third-year student on a medicine rotation. He was the attending/teacher on that team and began my early intro into the world of cardiology. He was a master teacher and physician and had the notoriety of being the best cardiologist in the East. I later trained with J. Willis Hurst—the best cardiologist in the South—when I came to Emory. Once again, I was blessed and fortunate. Remember the DeSanctis connection.

Fast forward again: About a year ago, I run into Hope Hines, the local CBS affiliate sports anchor, at a grocery store; and we exchanged comments and opinions about "silly" receivers dancing in the end zone and, upon reflecting, we were left wishing for the "time of Raymond Berry" when one could not discern, as he slowly walked off the field after catching a touchdown pass, if he was elated or "just doing his job." The direction of the conversation leads Hope to inform me that Raymond lives in Middle Tennessee and loves talking to Colts fans! I am simultaneously dumbfounded and excited. I get the nerve up to call him 2 weeks later. Raymond, being gracious, invites me to lunch in his new hometown of Murfreesboro, Tennessee, which is nearby, less than 30 miles from Nashville. We meet and I bring at least 50 questions about the

greatest game ever played, the 1958 NFL Championship between the Baltimore Colts and the New York Giants. As we connect and I get over the awe I feel in his presence, my phone rings and my wife, Doreatha, says: "Are you planning to come home?" We had been talking for over 2 hours. As we leave, we both say that we will stay connected.

Less than a month has passed and his wife, Sally, calls me telling me "that Raymond" is ill and at Middle Tennessee Medical Center in congestive heart failure. Raymond had a history of intermittent atrial fibrillation, for which my mentor, Dr. DeSanctis, saw him in the early 1980s. This condition, which causes the heart to race at a rapid and irregular speed, and if unchecked can overwork the heart and wear it out—causing a form of congestive heart failure, with accompanying shortness of breath, fluid buildup in the lungs, reduced endurance, etc.

Though I am pleased and flattered that Raymond and Sally would call me, I am a little apprehensive. But I realize that the Lord has given me an opportunity to help another fellow human, who happens to be Raymond Berry. The Lord puts circumstances in your life for a reason. Years before, He helped me understand that my role in life would be to help people with heart disease. He put me in a position to learn from the best teachers available and made it possible for me to have the knowledge and skill to help Raymond. Sally Berry told me that when Dr. DeSanctis was asked in Boston as to who should treat Raymond in Nashville, he said André Churchwell. You see how HE acts in your life? So I saw Raymond and with the help of Dr. Chris Ellis, a heart rhythm specialist, and the Vanderbilt Heart Team, we were able to correct the atrial fibrillation and get his heart back on track. I have been in practice for over 30 years and clearly recognize that we doctors and nurses and hospitals are here to help mankind; but there are times WE NEED HEAVENLY HELP. I HAVE SEEN TOO MANY SITUATIONS WHERE VERY ILL PEOPLE HAVE GOTTEN OFF THEIR DEATH BED to not acknowledge that we are effective only because of the Lord's help and assistance. Doctors get into trouble when we think that all of our successes are due to some unusual skill set. No way! Recognizing that chance and the Lord's help favors a prepared Doctor who has learned his science and his craft. So there was true triangulation occurring here: An iconic figure in the life of a young black kid from East Nashville who was fortunate to have been exposed to great teachers who shaped his skill set and professional mind—Roman DeSanctis and J. Willis Hurst.

Ray and Sally Berry are people of faith and Raymond talks at churches about his faith. I feel that my testimonial serves multiple purposes: It speaks to the presence of the Lord as the guiding hand in my life and our lives and to faith in his power and the recognition that we are tools to be used by Him for the good of humankind.

The last part of the story is "How does the Super Bowl fit in?" A week or so before the Super Bowl, Raymond was called by the NFL to carry the Lombardi award to the podium to present to the Super Bowl XLVI winner. He honored me by wearing the Vanderbilt Heart and Vascular Institute (VHVI) tie that I designed. You see four years ago, I designed this tie to be used as a

symbol to build esprit in the ranks of our Cardiology Faculty. So, 110 million folks in the USA saw the tie and around 1 billion worldwide. I am still waiting for the tie orders to come rolling in so I can retire!

Medicine, when delivered as described by my teachers reflects two axioms: patients and families feel that all doctors KNOW. BUT they don't know if they care. This is our greatest task. Lastly, in 1929, Francis Peabody of the Harvard Medical School, offered an admonition regarding the rapid growth of the scientific method and its potential to deflect the attention of students and young doctors away from patient care. At that seminal moment in the history of the patient-doctor relationship, he reminded us that the secret to caring for the patient is CARING FOR THE PATIENT!!

Lastly, one clear message from me to the youth of the church would be to find your passion— what drives you—and work hard to achieve it. As you achieve some success, remember that your unique skill, whatever it is . . . should be viewed as a "tithe" (a gift or offering). You should not hoard your skills; but as in tithing—share them with people! And in giving some of your self away, you add value to your life and serve the Lord Almighty.

I thank the men of the church for asking me to deliver the Men's Day speech; and I thank my friends Raymond and Sally Berry for coming today and allowing me to share this story.

I thank the church for asking me to talk today.

My last opportunity was a few years ago, and I focused on an unusual topic—"Faith and the Super Bowl." If you can remember back that far, I described a unique personal relationship that tied the flash and dance of the pagan ritual called the Super Bowl to what I felt was a spiritual intervention aided by the Lord.

Today, I was asked to offer a few personal insights during Black History Month. The routine talk would be on a figure of national prominence and review their life-story. I have chosen another approach.

Let's start by reviewing some nomenclature. Africans brought from coastal Africa should not be defined as slaves but an enslaved people—big difference—enslaved Africans strongly implies that our forefathers and foremothers, were brought against their will from their homes to the Americas. They were not transformed or morphed from Africans into this new being or person called a slave. No, they were free Africans leading their own independent lives who became enslaved Africans. Words matter because of how our brain processes the letters and words. I hope you can see and feel the difference between the two descriptions. Can't you?

To start with, I want you to reflect on as to who was the "greatest." To Muhammed Ali's credit, he said he was the greatest enough on the world stage and of course, delivered the "goods," that very few people of any race would deny that he was the greatest heavyweight champion. But I would offer, from this pulpit, a counter to Muhammed Ali's contention. I would say that a black man born on March 31, 1878 and who died on June 10, 1946, who stood 6'1" and weighed 200 lbs. and held the boxing crown from 1908-1915 was the "greatest." Author and movie maker, Ken Burns, said he was the most notorious and famous African-American on earth for 13 years. His name was John Arthur Johnson (Jack Johnson). Born the only son of 9 children to a black couple in Galveston, Texas. Galveston's unique income and geographic structure caused virtually all citizenry to be poor—white, black and all groups. All races lived together, given the geography of the city and the social leveling effect of severe poverty led to all races getting along. This led him to an early world view that blacks and whites were equal in skills and opportunities. There are many parallels between Johnson's life and Muhammed Ali's. Both were not only gifted fighters, but African-American men, who bucked the system. I would argue that bucking the system in 1919—which included marrying a string of white women, flaunting his worldly goods—clothes and cars—was a bit more dangerous. Such behavior under Jim Crow Laws in America at the time could have led to his premature death; but didn't. I think the life Jack Johnson offers us a unique example that if one has superior skills and courage, you may surmount the Mount Everest of your field—despite the times you live in.

Leonardo Da Vinci is a hero of mine. I marvel at his ability to wed so completely, the functions of the right and left brain. Right brain metaphorically is the seat of creativity—art, poetry, sculpture, writing—and a host of skills. The left brain is where deterministic thinking lives—math, science, computational and rational thinking. In Da Vinci, one sees the master painter—in his creation of the Mona Lisa—and master engineer—bridge design, weapon design, explaining the flight of birds, etc. Well, we have many gifted and creative African-Americans that can be brought out of OUR pantheon of heroes—such as inventor George Washington Carver and historian Carter Woodson. I would also argue and offer up for view and analysis that the celebrated, multi- talented genius of Gordon Roger Alexander Buchanan Parks. Born November 30, 1912 and died March 7, 2006. Author, poet, photographer and film director who documented African-American life. Mr. Parks became a staff photographer for Life magazine (1948), wrote a book of published poetry (1978); wrote his first book of fiction in 1963, followed by a string of autobiographies; became the first African-American to direct a major-studio film, "The Learning Tree" (1968); followed this with "Shaft" (1971). What is the lesson from such a varied life?

Continue to read and learn and stretch yourself. Explore your own skills and talents. Don't put up artificial walls around you covered with signs that say "I can't do this because of X, Y and Z." Let's examine Park's life:

- Magazine photographer at age 36
- Poetry book at age 66
- Directs first movie at age 59

Another important lesson the long lives of Da Vinci, Parks and others—like Robert Churchwell, Sr.—who wrote professionally up until age 90—tells you that when it comes to productivity, age is just a number.

Who is the greatest band singer, singing cowboy, and Hollywood actor you never knew or saw? How about Herbert Jeffries. Born September 24, 1913 and passed May 25, 2014. Real name: Umberto Alexander Valentino. White Irish Mom and Moorish-African American father. Jeffries became the band singer for Earl "Father" Hines and then as the incomparable Duke Ellington's featured singer. Their record of the song "Flamingo" was a hit; but the album covered by white singer Tony Martin sold more records. Also, Jeffries became the first and likely only black singing cowboy star in the mold of Gene Autry and Roy Rogers. Jeffries financially backed his own B-Westerns—"Harlem on the Prairie" and "The Bronze Buckaroo". Jeffries may have had the longest recording career of all-time: He recorded his last album in 2007 of original cowboy songs.

How about ending with the Black Leonardo you never heard of? In 1916, a number of tunnel workers were trapped in a water tunnel fire 50' below Lake Erie. A young black inventor rescued them by fashioning a hood to protect his eyes from the smoke and constructed a series of air tubes that hung near the ground to draw clean air into his hood beneath the rising smoke. This

allowed him to reach the men in the tunnel and save them. His name was Garrett Augustus Morgan. Born March 4, 1877 and passed July 27, 1963 (age 86). He had a natural skill in mechanical design and construction. His first job was repairing sewing machines for a tailoring company. He created the smoke hood, circa 1912, to work in a fire or smoke-filled compartment. This hood evolved to the gas mask used in WWI; other citations were hair straightening products for black hair. He also created a traffic signal (1922) that rotated warnings—not lights. The three-color light system was invented in 1920.

Why do we have a Black History Month or a National Medical Association or a Chi-Boule or Links, etc. There was a time that we had no choice but to celebrate, ourselves. We were not part of white society circles or events, and though we had black doctors, lawyers, accountants, etc., they were not allowed in white professional organizations for many years. Black History Month was created for that reason; but let's be clear: The history of black Americans is a reflection of the history of America, as are the lives and careers of Asian-Americans, Hispanic- Americans, Hawaiian Americans, Native Americans (American Indian), LGBTI Americans, and disabled Americans. America has slowly and inevitably had to claim these "outcasts'" lives as American lives. Why, because in many cases they built—physically—America and added to the richness of not only its musical, but political and scientific history. For example, the year 2017 was the centennial year of Dad's birth—September 9th, 2017. But Dad was not the only African- American of historical importance born that year. Other powerhouses born that year include Dizzy Gillespie, Lena Horne, Jacob Lawrence, Ella Fitzgerald, Fannie Lou Hammer, Gwendolyn Brooks, Isabel Sanford, Thelonius Monk, Ossie Davis, Mayor Tom Bradley and blues legend, John Lee Hooker, and others. Wow! Talk about a year; but look at the contributions these folks made to 20th century American history. One lesson: who knows what genius and meaningful lives will be born this year. It makes the case to value every human life and work to help every child realize their full potential! This why we must continue to re-invent and develop our public school systems.

In closing, what is my message for Black History Month: As we celebrate the successes of African-Americans, let us continue to do the research to uncover those, whose lives have enriched this country of ours. Go past the well-known figures to those whose lives have landed in the museum of anonymity. We at VUMC have undergone such introspection last year and realized many African-Americans and other minorities who, though we may not be doctors and whose walls are not laden with degrees, have helped build our world class medical center.

Let us bring these unknown African-American men and women out into the light to illuminate their successes, and look hard to see what we can learn from them to improve and elevate our own lives and the lives of ALL Americans.

It is like Robert Frost's poetic admonition about how "a road not taken" can lead to a rich life. The road for many young African-American children could

be the road NOT viewed as one destined to greatness. Their road is NOT one paved with smoothly laid cement with four lanes and sidewalks. No, their road may be one of uncrushed rocks and dirt—a road covered with boulders and fallen trees all serving as barriers as they make their way. But with the help of their family, their church and an undying commitment by their communities to our true American Spirit of hope and unwavering support,
African-American children will find their destinies fully-realized on their "road not taken." And when they finish their journeys, we will see the fruit of their bountiful lives—lives lived as doctors, presidents, scientists, artists, inventors, librarians, teachers, lawyers—all contributing to this country—America. Yes, then we can fervently echo that profound sentiment of Mr. Frost (quote): "I took the road less traveled by, and that has made all the difference."

HEARING VOICES

I recently cared for a middle-aged woman who had severe calcific rheumatic mitral stenosis. By the time she arrived at our hospital, she had seen a number of cardiologists, all of whom had informed her that her condition was inoperable. Her pulmonary artery pressures were near systemic levels, and she had undergone multiple right-side heart catheterizations to determine whether her pulmonary vasculature was at least partially responsive to state-of-the-art vasodilators. To my surprise, her pressure-loaded right ventricle had normal contractility despite the confirmed high and fixed pulmonary vascular resistance created by the highly stenotic mitral valve. After reviewing the case, our senior cardiac surgeons were reluctant to operate. Furthermore, the lack of valve pliability and the marked calcification caused our most intrepid mitral valve balloon operators to purposefully avoid me in the halls of the hospital.

So here I was, stuck with a dilemma with morbid consequences and no obvious way out, short of "medical therapy." In such times in my professional life, I have looked to mentors who had more experience and wisdom than I. In fact, I strongly believe that we need mentors of all kinds in our lives. For example:

- Life Mentor. My life mentor was my late father, Robert Churchwell. As Dad became ill and eventually terminal, I realized that he had partly spent the 92 years of his life preparing me to "go solo." Fortified by his lessons and messages, I have been able to make good decisions in tough family times and to maintain some semblance of balance in my life.
- Medical Administration Mentor. For me, this job fell to two people. John Stone, the late poet-cardiologist at Emory, worked with me in my first job as Director of Minority Affairs at Emory. John's heart and soul informed every decision, easy or hard, that we had to make. He helped me understand the importance of not allowing the intrusion of technology (important as it can be) into the delicate balance of trust and intimacy in the doctor–patient relationship. Then for years, Dean Daniel Federman of Harvard Medical School has offered words of support and caution as I have ventured into such new realms as curriculum development. As more complex academic medicine hurdles approach, I try to keep myself open to "hear" my mentors' words of experience.
- Clinical Mentor. I often hear the lessons of the pantheon of clinical mentors who trained me at Emory—such as J. Willis Hurst, R. Bruce Logue, Ed Dorney, and the other wise practitioners of cardiology and medicine. When I am about to slip off the road and make a medical mistake, I sometimes hear Joe Hardison ("Country Joe" to his residents), the former Chief of Medicine at the Emory Veterans Affairs Medical Center, exclaim, "Why did you do that, André?" Many of these teachers have passed on, but their lessons and voices resonate in my active memory to caution, teach, and support me in the care of my patients.

In the case presented above, I called another great mentor, Roman DeSanctis, at the Massachusetts General Hospital. You see, I was fortunate as a third-year student to fall under his instruction for one month. A single month can leave a lasting effect on the mind of a willing student. His dedication, scholarship, and commitment to his patients were, and are, unwavering examples of excellence that I can only strive for. He has answered my call on a number of occasions during the past 30 years of my practicing career, and he did so in the case in question. He informed me that if the left atrial pressure was high enough, the pulmonary circuit would be so "stuffed" and congested that pulmonary vasodilators would not work. But if the left ventricular end-diastolic pressure was normal, the patient in fact could benefit from mitral valve replacement. So, after some prodding of the cardiac surgeon on my part, the patient had a successful surgical outcome.

Although perfection cannot be fully achieved, striving for the unreachable can make us better human beings and better physicians. Mentors play a key role in this life journey and, oftentimes, serve as road signs to direct us. I hope that our younger colleagues will understand this principle and spend their lives developing a "listening ear," in order to hear the voices of their mentors.

Reprinted with permission from Texas Heart Institute Journal (Volume 40, Number 2, 2013, pp 123-124).

Daily Devotion-Letter to the Editor for The Pharos

Physicians are not immune to the medical illnesses they treat and unfortunately are at higher risk for a number of ailments and their consequences ranging from alcoholism, drug dependence, and suicide. The growing stress that physicians incur from the practice of medicine is akin to a psychological plaque that is competing for the soul of medicine and diminishing our age-old mandate of knowing and caring for our patients.

How do we therapeutically address these problems that gnaw away at our cherished position in society and diminish our value as true professionals? The horrid pace of the practice of medicine has altered the doctor's and the public's perception of what it means to be a doctor. In past years, physicians were viewed in many cases as extended members of the family and, if not that centrally connected, at least as part of the extended family community. With physicians often unable to spend time to build those personal bridges that connect human to human, our worth and society's respect for the physician has waned, much like the recent value of our mutual funds in the stock market. Once again, how did this happen? Some would say that the pressure to see more patients in a time of declining reimbursement and the mountain of paperwork that must be completed each day have created impediments for thoughtful nurturing behavior needed to fully develop the doctor-patient relationship.

In years past, there were visionary medical leaders/writers like Francis Peabody, J. Willis Hurst, Sir William Osler, John H. Stone, and others, whose values and inspirational writings helped to keep us sane and on course. I believe writers like these icons have unique insights and answers on the inner workings of the melancholy physician heart. I would profess that with the challenges medicine faces, we need to revisit the writings of current and past physician/writers for daily inspiration. As some doctors read the scriptures in the morning to find solace in a troubled spiritual world, we need similar "daily devotions" to inspire us to handle the daily stressors and obstructions to better patient care. It is only when we try to exceed the current minimalist expectations and provide patients with knowing and caring treatment that we actually reach the goals and standards that we set for ourselves at the start of the long journey to become competent physicians.

Certainly, there are other forces at play that continue to challenge our ability to stay on the road to physician wellness for the greater good of our patients' health; but let us not diminish the power of positive thinking and the cogent lessons of self-regulation that are fortified by effort and faith. In conclusion, it does require a daily devotion of words imbued with the wisdom of Richard Selzer, Eugene Stead, Lewis Thomas, and others who entreat us to exceed

the norm and connect to our patients in ways that show that we "know and care." For it is only by completing the avalanche of paperwork, the elongated phone calls to obtain clearance to perform tests, resolving claim denials, and other seemingly perfunctory tasks, that we can ultimately serve our patients. These obstructions and other challenges to the sanctity of medicine can only then be viewed as a means to an end—the best care for our patients.

Andre L. Churchwell, MD
(AΩA, Emory University, 1979)
Associate Dean for Diversity
Vanderbilt School of Medicine
Nashville, Tennessee

Published with the permission of the editor of The Pharos.

THE TENNESSEAN

"TENNESSEE VOICES"

Mentors change peoples' lives and careers forever

The education of Alexander the Great was entrusted to a teacher of immense skill and wisdom. His name was Aristotle. Though the name Mentor is derived from Greek mythology, it was Aristotle's role as Alexander's mentor that defined the word. From this origin, mentor has become forever associated with a personal teacher, an intellectual role model, and life-long friend. I recently lost a great mentor, Levi Watkins, Jr., M.D.—a man who committed himself to several noble efforts—the civil rights of the downtrodden, developing the lives and careers of young minority physicians in academic medicine, and serving as an oracle on the struggle for equal rights for black people in America.

His was a life like a bottle of cherished fine wine—savored and meaningful until the last drop. He, like many men of destiny, was on a life path to make a difference until the last moments of life. Such was his case, as Dr. Watkins was mentoring medical students when death suddenly claimed him.

Fortune afforded me the chance to meet him as a second year medical student. I was set on a career in cardiovascular medicine and he, at this point in 1979, was beginning his storied surgical career at Johns Hopkins Hospital. I was sent to meet him by medical school mentors who felt he would offer me sage advice.

I arrived in Baltimore from Boston, excited and hopeful and, after meeting him, remained under his demanding, thoughtful, and career-altering tutelage for nearly forty years.

Good mentoring has such a pivotal role in the growth of a career-minded person. One of the challenges of the single-parent family, often described in the African-American community, is the lack of the other parent-mentor-guide. It is for this reason, that successful programs that address the Kindergarten through college career arc of African-American males maintain demanding, but loving mentorship all the way to college and in some cases, beyond. It is why programs like "100 Black Men and 100 Black Women" have such a positive effect on the careers of young African-American students. My contention is that, to address our larger STEM (science, technology, engineering and mathematics) problem in public education, such life-long mentoring will be essential and must not be minimized or neglected.

A few years ago, I wrote a piece on mentoring called, "Hearing Voices." In this piece, I outlined how a young, aspiring academic physician requires multiple types of mentors to be successful. Some mentoring skills may be resident in a single person; but, in many cases, one needs multiple people to serve his or her needs. I cited examples, such as a life-coach/mentor: This was served by my father, Robert Churchwell. I personally required a clinician/educator mentor: This position was filled by the legendary bedside genius, J. Willis Hurst, MD. Each mentor was sought out for their unique skill set. Once I

recognized their value, I stayed closely connected to each for their lifetime.

As we begin a new school year and Nashville continues to grapple with the problems of our under-resourced inner city schools, it is incumbent upon us to recognize that we do need money and physical resources to improve our schools; but the human capital of effective mentors are equally essential.

Many scholars of history point to the lessons and instructions of Aristotle, coupled with Alexander's genius in applying these lessons in warfare, as directly influencing his success as a conqueror of nations. Let us hope, that in investing in effective mentors for our students, that their influence will aid them in conquering the great problems of science, healthcare, and other societal ills.

Ode to 1917, a celebration of Dad's 100th birthday

1917 is an odd year to write a thought piece about, but it was a year that ushered in many Americans who shaped the 20th century. How about Hollywood celebrities like Lena Horne, Dean Martin, and Ossie Davis; and, in sports, legendary Boston Celtics coach Red Auerbach, and Olympian Louis Zamperini; in politics, President John F. Kennedy, Los Angeles Mayor Tom Bradley, and Indian Prime Minister Indira Ghandi; and lastly, in the arts and letters, bebop trumpeter Dizzie Gillespie, creator of Marvel Comics heroes Jack Kirby, painter Jacob Lawrence, and Robert Churchwell, Sr., the Jackie Robinson of southern journalism.

One could sing, as Sinatra did in his thoughtful lament that in fact, "It was a very good year."

Dad's centennial is September 9, 2017. It is hard to imagine that he would be 100 years old if he were still alive (passed February 3, 2009). You are lucky if you encounter a single transformative figure in your life, who will shape your values, interests, opinions, and choices.

My father was that transformative figure in my life. With great care, he lived a modelled life, mirroring for his children why he made certain choices in matters small and large, and important and trivial. His influence was such that he affected the lives of almost everyone he encountered, such as the journalists Reginald Stuart (formerly of the New York Times) and Dwight Lewis (former editorial page editor of the Nashville Tennessean) and scores of youth at his home church, Seay-Hubbard United Methodist Church.

On September 9, 2019 (his100th birthday), at the Seigenthaler Center from 1:00-3:30pm, the Churchwell family and friends will hold a celebratory event to chronicle his life and times. The public is invited.

I wrote a piece about him for the Tennessean on Father's Day, June 16, 2013. This piece, for me, captures his elemental essence. It is reproduced here for your pleasure:

Eclectic dad shared all of what he was

Special lessons inculcated over the years. Some through repetitive whiplash wrist motion. Some through gentle aspirational messages with final permanence in sweet memories.

He had no explicit model.
He fashioned his own epigrams and soul from Shakespeare, Thomas Wolfe, Langston Hughes, Hemingway and the poet Arna Bontemps.

Later, in our small domicile, his impulsive exultations, stimulated by Beethoven, Louis Armstrong and Mozart's Don Giovanni, were both evocative and commonplace, and thankfully frequent.

Cherished small televised gray images on Saturday morning transported Richard Tucker and Leontyne Price to 707 North Ninth Street.
Verdi didn't even know.

Floors hand-waxed, bathrooms cleaned spotless like a virgin operating room.

Saturday's weekly Herculean labors softened by the music of Sinatra, Ella, Jerome Kern, Paul Robeson and both "Mack the Knife"s.

Daily lessons were subtle instructions and examples of a virtuous life.

An older son at medical school beset with stolid faces and a room bereft of air conditioning was visited by him.
And he slept on the floor.

Weekly letters sent with the certainty of a sunrise connected his son to him, to life, and communal love.
Funds from "The Unknown Source" paid medical school bills and paved the road to the future. He shared all of what he was.
Love guaranteed and endless "preparatory sessions" for the son to go solo.

He is gone now, like Pompeii.
He was as wise as Erasmus until the last second. His lessons etched in the son's soul. A long life and many lessons shared.
He was not selective, his wisdom and love were freely dispensed.

No physical monument for him but progeny with his name and humor who seek to preserve the memory of his grace and who recite his intensely unique journey.

His legacy is that mercy, love and service must be taught, shared and perpetuated. For him, this was the meaning and purpose of a complete life.

The enduring image of this bald but mighty Samson remains clear and deeply entrenched in memory. DNA is generational but seminal lessons and values—like his heavenly soul—are immortal.

A doctor's view: Take vacation to rest, relax, recover

Being a physician has its challenges when it comes to vacations. There are no "seasonal breaks" in your schedule where work naturally and purposefully slows down—consider, some workers have the summers off. So when you examine time for a vacation, you have to insert it the midst of a never ending schedule of patients to see, meetings to attend, CME credits to obtain, etcetera, etcetera.

Vacations do have great value. They are a time to re-charge your batteries; a time for mid-year honest reflections; a time to work on your tan; catch up on non-medical reading; and address a host of tasks from your honey-do list. The late Dr. J. Willis Hurst, one of my great mentors, in his usual well-thought out manner, took the entire month of August off. He would leave his hometown Atlanta and travel to a remote family vacation spot, away from the interrupting effects of the telephone—this was in the pre-cell phone and internet times. There he would plan his next textbooks, finish writing scientific papers, catch-up on personal letters to friends and trainees, review layouts of books in development, take long walks to help in the incubation of new solutions to old problems, and read articles and books to fortify his mind for the coming challenges of the remaining year. His was a modelled life for all he trained, including me, sharing all those aspects of his life that might serve as useful tools for our self-improvement.

As I pen this essay, I am on vacation in the tiny hamlet of Pinehurst, Georgia, located in middle Georgia, adjacent to the larger town of Cordele, Georgia—"The Watermelon Capital of America." Home of elongated flat vistas, working farms, and an overabundance of aggressive mosquitoes and gnats. Pinehurst is my wife's hometown and where her large family lives and congregates during family vacations. This literal "hot spot" (current breeze assisted temperature is 100 degrees F!) offers different views from middle Tennessee. Gazing out the front door, one sees row upon row of cotton, imbedded in the bright Georgia red clay dirt. No hills, no mountains, no wind, but the smell of great home cooking. As we line up for the first of four meals to come, I consider grinding up a statin—a cholesterol lowering medication— and without notice, quietly sprinkling it on the delicious calorie laden food. My Muse prevents me from such a clandestine act because she knows (I hope), this high-octane high calorie populated food will serve as a summer catalyst in the creation of new ideas and epiphanies for coming projects. Such is my rationalization, as I agreeably ingest this southern cuisine. Also it is considered "a southern family dining crime" to not eat everything on your plate and ask for seconds!

One of the many benefits from vacations is that one can sleep longer. During standard working days, I normally rise at 5 am. During vacation week, I begin the day at 8 am. Scientists tell us that one cannot "catch up" on sleep. In spite of this fact, I arise refreshed and renewed. Science notwithstanding, I will accept the benefit of my placebo aided sleep. As I close this set of summer ruminations, I harbor a secret wish that after one of my many long midday naps, that upon awakening, I will find this year's acrimonious and contentious

political season was a bad nightmare. Unfortunately, reality will bring my folly to an abrupt conclusion, as the blaring televised voice of CNN reveals the all too shocking reality of Trump and Hillary. As I turn off the TV set and arise from my comfortable recumbent position, I make a mental note that for next year I will leave the TV and radio at home.

P.S. Have an enjoyable summer vacation!

Ponder 2014 and reflect on goals for 2015

As the final days of 2014 play out, it affords us time to ponder personal events that occurred in 2014 and to reflect on those coming in 2015. As a member of the melancholy group who have birthdays near or after Christmas (mine is December 27), and lament the absence of birthday gifts, I will spend time forecasting or outlining projects for 2015; some of which will address modifying attitudes and behaviors that will improve friendships and personal relationships.

I resolutely believe that it takes as much critical thinking to enhance human relationships as it does to solve complex mathematical equations or to unravel the diagnostic challenges of a puzzling patient. As part of a yearly ritual, I pull my page-worn diary from its secret location around New Year's Day. Next, I assess a grade for last year's sincere but, oftentimes, failed efforts. I then create a list of people with whom I will work to improve my personal relationship. The people listed vary from family and friends; to colleagues; to people I encounter in the course of my long days at work. I was taught that you never know when you will need the assistance of someone or anyone—no matter their social station or position in life. Don't consider your job or your socio-economic status as a shield against the challenges of daily life. An elevated job status only offers different challenges. And, of course, illness and death don't present a pass to the wealthy. We all need help. Some, more than others. All human beings have value and a purpose in this transient existence called life. So I view this yearly reflection as a necessary function of my own "Continuous Quality Improvement Program"—a concept borrowed from my daughter's corporate world. You see, mankind gets into trouble when it concludes that some people have a greater or lesser value than others. Much of our recent social ills can be traced to what my father called "narrow-minded thinking," perpetuated and enhanced by the blind spots of unconscious bias and our periodic collective lack of good will towards our fellow man and woman. Civilization and humankind progress when they hold a single life as a precious unique creation, to be cherished and nurtured. We have no crystal ball to inform us when the next Einstein or Martin Luther King, Jr. will appear, so we must value each life for its limitless potential.

As I begin my 2015 diary entry, I will encourage myself to ruminate and express on these pages some hierarchy of importance for the projects and challenges of the coming year. As I seek solutions to the outlined problems, I will, in addition, charge myself to remember again, the unique value and role that people of all races, religions, and ethnicities will have in their solutions. It is through their support, that my role as a physician and a committed citizen of this city, state, country, and world may be fully realized.

One of my great mentors, the late J. Willis Hurst, MD, of Emory University, wrote a paper entitled "What Good Doctors Try to Do." In this short but insightful piece, he laid out what doctors, who are committed to be better, try to do each day. My yearly exercise in self-reflection and forecasting is

a small attempt to try and chart a personal course to "Try to Be a Better Citizen."

Lastly, it is said that your life is a work in progress. It is my hope that my attempts in "trying to be a better citizen," will inch me closer to this goal and keep me committed to the democratic principle of valuing <u>All Lives</u>.

Reunions: signposts along life's highway

Late May and early June bring that annual rite of summer—graduations. Unfortunately, at this time, reunions are oftentimes lost amidst the celebratory events of weddings and graduations. The litany of reunions includes: class reunions, school reunions, family reunions, and reunions of all kinds! I recently attended my 35th medical school class reunion. It doesn't take a chronologist to know that, by now, I have received my AARP card and can take my appointed place with seniors at public events! Acknowledging that I had missed our 25th and 30th reunions, I was intent on making this one for a host of reasons. Some reasons were tied to the emerging recognition of my own upcoming mortality—hopefully not hastened by writing this piece! Other motives were connected to a wish to see "old friends"—classmates, teachers, hospital halls I walked in altered states of consciousness, and the ancient buildings that housed our classrooms and hold fond memories.

One of the important consequences of such an event is that it causes you to consider the course of your life: its past, present and future. One common observation we collectively noted is that modern medicine, as we have witnessed its evolution, is full of impediments to forming a close doctor-patient relationship. The obstacles range from excessive paperwork, growing information technology encounters, and an overwhelming number of new patients to see. These challenges, though some more necessary than others, put the aforementioned doctor-patient bonding time at risk.

Our alumni visit offered my classmates a moment to review the reasons we chose medicine as a career in the first place. At the time, we viewed it a chance to apply science in a manner to serve humanity and it offered us the unique opportunity to serve mankind through equal doses of science and humanism.

I left my classmates reinvigorated and more committed to find moments in each day for self- reflection. Hoping that reading the works of writer-physicians such as Oliver Wendell Holmes, John Keats, and others, would help fortify my resolve to practice medicine and to recognize the impediments to care, as a means to deliver excellent patient- and family-centric care.

There is value in reunions that reaches beyond the obvious and I will plan to revisit my medical school Alumni Day and class reunions as often as possible. Along with many other lessons learned, I wrote in our class journal, that life itself, with its losses, successes, deaths, childbirth, and hosts of challenges, has made my classmates and me more alike than when we entered Harvard Medical School in 1975. Then, our natural impulses and "juvenile" competitiveness created artificial barriers that, thankfully, time has erased. It is in the crucible of life and rigorous medical training that our struggles can humble us and assist in making the next patient encounter a deeper and richer experience for us all.

In closing, reunions, more than any other ceremonial event short of a eulogy, serve as a penultimate sign post on life's highway. A sign post where one can stand and look back at the distant road signs of youth and early successes and failures, and then looking forward, one sees the not-too-distant sign posts of one's final purposeful acts. I quietly listened to classmates speak of future retirement plans to travel, learn new languages, visit grandchildren more frequently, and to spend more time with their significant others. We spoke of common lessons learned and how life's trials lead to greater maturation and relishing each sunrise. Thankfully, the overly-competitive nature of young medical students, has given way to a more mature, shared sense of our common roots—medical school and life's eventualities of loves and losses. I look forward to more reunions, as I now recognize how they will aid in shaping my growing appreciation of our common frailties and the precious immeasurable value of <u>each</u> single day.

Visit to Italy brings home U.S. soldiers' sacrifice

My wife says that I am a genetically engineered workaholic. From observing my busy siblings, I would have to agree!

So when she devised a two-week trip to Europe this June to celebrate our recent 30th wedding anniversary, I was plagued with thoughts of "work withdrawal syndrome" (my own diagnosis!). This is characterized by the constant body search for your missing beeper/phone and continual worrying that you have forgotten to do something. Once we landed in Rome and inhaled some vino and a few scoops of gelato, I was temporarily cured of this "malady."

After three days of overwhelming Roman beauty, ancient relics and pasta, we took the bullet train to Florence, home of the Renaissance. While there, we saw a multitude of paintings, museums and statues that I had carefully studied nearly 40 years ago in art history courses at Vanderbilt. The classes were taught by the eloquent Puryear Mims and the fluent Hamilton Hazelhurst, whose descriptions of Renaissance art reside in my happy memories as permanent visual aids.

After securing our rooms, we sped through the Tuscan countryside on two-lane highways, chauffeured by an apparent Italian "NASCAR" driver. As we negotiated a series of tricky narrow serpentine roads, we suddenly came upon an astonishing vista. There, before us, on a manicured sloping hillside, were row upon row of marble headstones. They were laid out in a precise geometric pattern and order. A quick count, and I estimated 3,000-4,000 in number. At our request, the driver pulled into this serene and lovely place.

We gazed up at the entrance and saw the American flag, hoisted high, blowing majestically in the wind, and the simple sign, "Florence-American Cemetery." We had stumbled into an American World War II cemetery created for brave souls who, as Lincoln said, "gave the last full measure of devotion."

It was near closing time, and as we approached the entrance, a young man walked from a small building to greet us. He said that we could visit the grounds and tour the magnificent marble memorial at the back of the cemetery. As my wife and daughter went their way, I stood alone with my thoughts. I carefully and slowly walked through rows of graves near the entrance and quietly read the names on the headstones. Young men and women from places like Madison, Wis., Norfolk, Va., and from nearly every corner of this great land.

I reflected that my dad could have been here, short of providence or serendipity. He was in the Italian theater of World War II and, at unsolicited moments, would discuss, albeit very briefly, some of his experiences in Italy. The young caretaker asked me if I would like to lower Old Glory and fold it. Suddenly and unexpectedly, I recalled from deep memory my Cub Scout

instructions on the proper technique to fold the flag. This process became quite an emotional moment for me. In its sum, I felt my act was a small, personal gesture to honor the brave Americans buried here.

We in America, all too often, forget the great losses of wars — both past and current. Losses of cherished fathers, sons, daughters and wives from all races, ethnicities and religions who don't come home. Wars don't discriminate when it comes to who dies. We know that lives and families for generations to come are permanently altered. I found some small solace in viewing the profound grandeur and beauty of this final resting place for our American brothers and sisters.

The caretaker informed me that he had just replaced a family who had served in his role for more than 25 years. He smiled at me and said, "I will be here when you return in 25 years. We value what these soldiers did for my country, and those who serve in my role in years to come will never forget."

Vacations are times to visit and see the beauty of God's creations. They also afford you opportunities to bear witness to events and people, known and unknown, who have shaped history and made the way clear for us to live free in this great country.

The caretaker was right: We must not forget.

Strong work ethic pays off for entire life

My children have said for years that I'm a dinosaur. It is now finally true. On Dec. 27, 2013, I reached my sixth decade on this spinning blue orb we call Earth. Every birthday brings more reflection on what is left to accomplish and achieve in the remaining time the Lord has allotted. As I ponder my future, I know, regardless of my few God-given gifts and education, I owe most of my limited success to just plain hard work.

Hard work is the foundation of the American ethos that has led to the growth of this great country in less than 400 years. In comparison, Europe and China have civilizations that stretch back, in some cases, thousands of years. Clearly, we stood on their shoulders to achieve our successes and rapid growth; but nothing would have occurred if we were phlegmatic do-nothings.

My dad and mom made it very clear that we had to work hard to be successful. Our less than fruitful searches for a sinecure only fortified their message! "Burning daylight," in general, was not allowed in our home. Dad, working for The Nashville Banner, had to rise very early to be in the city room to finish and turn in his copy. This usually meant being awakened daily by his ancient transistor-tube radio at 4:30 am. Whether this was intended or not, the melodious baritone voice of Bob Bell on WSIX radio served as our morning wake-up call for years.

'Family Financial Support Fund'

There were no summers spent languishing on beaches or watching endless television programs in our recently air-conditioned den. Nope, we had jobs to help defray college expenses and to assist our parents with their "Family Financial Support Fund." To provide my part of the fund, I recall spending an entire summer working for my uncle's janitorial service, cleaning all 20-plus bathrooms in the newly constructed Andrew Jackson State Office Building and sweeping the roughly 100-yard-long parking lot of the Cavalier Building on White Bridge Road.

This leads me to discuss the concept of Hard Work. The definition of Hard Work is century- dependent. I am sure the slaves that built the Egyptian pyramids would consider building modern skyscrapers as less laborious and dangerous work. I am also certain that American laborers of the early 20th century would not consider current jobs that require us to sit for hours, staring at a computer screen as "work," either. From a personal perspective, hard work in my father's home consisted of using the large major muscle groups of the body (hips, shoulders, calves, etc.) in repetitive, nearly continuous, sometimes painful movements that generally encompassed hours of activities, e.g., cutting the lawn, cleaning all the windows in the house (outside and inside), hand washing and waxing all the floors in the house, etc.

Now, my lovely wife of over 30 years, Doreatha, smiles when I discuss the "hard work" my siblings and I were charged to do. She was the middle child of a family of 10 children of a south Georgia, African-American cotton farmer. Her description of hand-picking cotton during the hot and steamy Georgia summers from dawn to dusk and missing school days to complete these tasks have reshaped my definition of "hard work."

Building perseverance

Where am I going with this? Well, I can't be absolutely certain there is a clear and direct correlation to the degree and extent of hard work and the useful adult behaviors/skills of resilience, perseverance and motivation, but I suspect there is. For humans, repetitive activities silently train our motor system and frame our capacity and tolerance for extended periods of mental and physical labor. One has to think that the current generation of children who view "work" as solving tasks via a computer and using the computer to reduce or simplify tasks is missing some important skills and lessons that will come in handy later in life. If you don't finish a task, such as cleaning all those bathrooms in the Andrew Jackson State Office Building, you will pay the price when your work is inspected! Recognize that this work is physical and has a result that is easily measured and graded. If one has to continually work past the "stop time" to redo or complete your job, it will inform and shape your work ethic and your idea of when a task is truly finished. This will resonate for years in every small and large job you are required to do.

Lastly, I feel that the children of today need opportunities to experience these forms of education and behavior-shaping encounters. It may be that part of our drop in the worldwide secondary school rankings is at least partially tied to the lack of value or the casual attitude that many students have developed toward Hard Work.

That idea is, at least, worth the "effort" of sitting and a moment of reflection.

Bennett's voice shows 'Life is Beautiful'

I have been called a walking anachronism. While my baby boomer friends were dancing in high school to The Temptations and the The Four Tops, I was being schooled by my father on the unique musical qualities of Frank Sinatra, Nat Cole, Ella, and Tony Bennett. I am told, there is a place in the mid-brain where music is processed and appreciated. I recently heard of a condition where people have no musical interest or taste. They must have been cursed by the gods, or something. I recently read that Sinatra never listened to himself at home and preferred classical symphonic music: this was reflected in his massive record collection of works from Mozart to Haydn.

Recently, we were fortunate to have 87 year old Tony Bennett grace the stage at the Tennessee Performing Arts Center and deliver his unique style of singing—a blend of jazz expressionism and sophisticated swing singing. I am a physician by training and am dumbstruck by his youthful vigor and the unerring pitch and quality of his voice. Singer's careers are dependent on two thin, potentially fragile, muscular structures called the vocal chords. We are all aware of singers who prematurely lost their voices due to the delicate nature of those two little muscles—such as Julie Andrews, and for a short time, late in his career, Andy Williams. So to see Tony still hitting those high C's and E's just blew me away.

I have read all of his recently published books, e.g., his memoir, books on painting, and the deeply personal "Life is a Gift." The last book offers us a window into Tony's soul. He implores us to love and not hate; listen to our creative side for it will bring joy; value people and friends; and search for beauty in your life. Given its text, it could have been penned by Thoreau or Oscar Wilde. Tony, like many great artists, recognizes the fleeting nature of life and like the Astaire song he loves to sing, "Life is Beautiful in Every Way," we must look for joy and beauty each and every day of this frenetic existence we call life. For in finding brief glimpses of beauty in song, painting, poetry or nature, it slows the pulse and offers a moment for reflection, albeit briefly, of what it means to be human and humane.

That is a lot to get out of 8 bars of music.

SARTORIAL MATTERS

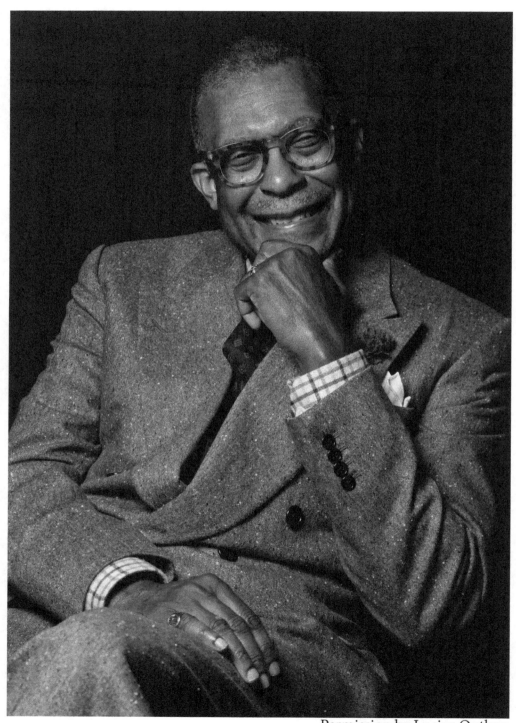

SARTORIAL MATTERS

My interest in men's dress was sparked by my omniscient father. Dad was a product of the early 20th century, when young men took their sartorial cues from the 20 foot cinematic examples provided by Clark Gable, Gary Cooper, Fred Astaire, Cab Calloway, and scores of stars who men's dress writer, G. Bruce Boyer would describe as "pressed to their bone marrow." Young men of Dad's generation understood in a detailed fashion, how your dress shirt, jacket, and trousers should look and drape. With such encyclopedic knowledge at his beck and call, it was only natural that he could interest his sons, me included, in the art and effect of men's dress on the fairer sex.

As I am prone to do, once presented with a new topic to learn, I set about creating a sizable library on men's dress, with special attention to the 20th century. Once armed with the means that a college education and a successful career could provide, and aided by providence, I have been fortunate to meet men's dress writers and arbiters of style, including Alan Flusser, G. Bruce Boyer, Robert Gillotte, and a flock of bespoke tailors and hatters.

After receiving my "post-graduate education" on men's dress from this knowledgeable team, I was introduced to my current English tailor and friend, Leonard Logsdail. Our relationship, initiated by G. Bruce Boyer, has been one dedicated to enhancing my positive physical attributes and attempting to cover my physical infirmities. In most instances, he has been successful.

In the following essays and pictures, you will be introduced to my sartorial passion and its effect reflected in my essays and photographs set forth here to reveal in pictorial format, my ideas of men's dress.

These articles were written for FLIP Men's Clothing store's blogsite and is reproduced with their permission.

Enjoy!

FALLING FOR FALL DRESS

Fall is a great time for dressing! Nature's palette is bright, highly tonal and rich—burnt orange, hunter green, autumnal range and red. These colors offer men multiple opportunities to uplift solemn spirits with the vivid colors of fall. In spite of these almost blinding hues, we still face challenges with current male taste in dress. I see a recurrent vision—the woman dressed to the nines for a night on the town and her escort, dressed as if he is attending a freshman beer party! What's wrong with this picture? As in most things in life we look for symmetry and balance, why can't this occur in men's dress? A man would never buy a car that he didn't analyze and dissect from headlight to back fender—why should there be a different set of rules for dress? What one wears is as much akin to a signature or fingerprints as anything we own or display. Women love a guy in a flattering suit—wise up!! That's why Cary Grant is still revered and adored by women more than twenty years since he passed and when this sartorial icon was alive, he was packing them in on one-night stands delivering testimonials on an age and life we acknowledge as the golden age of style and dress. Guys who understand the magnetic power of dressing with style don't relish the extra competition, but it would improve the passing vision of the usually boring business attire cattle-call. Dressing with style is an amalgamation of choosing clothes that fit one's build, sensibilities and personality. Once one masters the basic tenets of dress, the galvanizing effect it has on the casual observer becomes like the trick that a great magician never exposes.

Another problem modern man has is the lack of current day sartorial role models—hence our dependency on icons of the past. There are scant numbers of men on the world stage who young men on the path to self-invention can aspire to emulate. The ambassadors of FLIP can serve as a partial solution to this problem!

Appropriate dress is one small brick of the rock of Gibraltar that I call civilized society. As we devalue dress, small chunks of civilization are lost—this would also include the growing absence of the exercise of good manners and acknowledging our elders.

Let us celebrate fall and its colors and seek models of dress to elevate men's dress back to its place of importance in our society!

Please enjoy the flannels, tweeds, suede shoes, cashmere and woolen ties and allow your own personal style and taste to flourish!

I look forward to sharing more ideas and stories of the history of Men's dress.

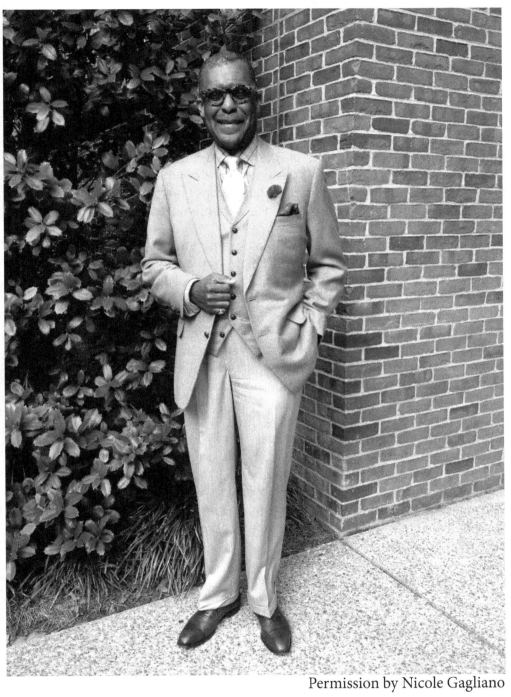

Permission by Nicole Gagliano

TO BE (BESPOKE*) OR NOT TO BE . . .

My day job is not connected to men's dress or fashion, but I have a passion, nonetheless, for this topic. I suspect that it was my Dad who introduced the concept of appropriate dress for the occasion. For him, a clean, white, starched, button-down, beefy Oxford Brooks Brothers shirt was de rigueur and a necessary part of his daytime "armor."

Fast forward to the 1990's . . . I'm in Atlanta and looking to expand both my wardrobe and knowledge about modern men's dress. Thanks to a lucky break, I meet G. Bruce Boyer, the Dean of men's fashion writers, who introduces me to John Vizzone of Ralph Lauren, Leonard Logsdail—a Savile Row custom tailor located in NYC—and a host of other luminaries of men's style and dress. In my post graduate education, I learned about the sanctity of bespoke tailoring and the importance of personal style and taste.

Don't get me wrong . . . I love bespoke clothing; but the pragmatist in me recognizes that to have a wardrobe replete with custom clothing would require a royal treasure of at least a Duke . . . of Ellington or of Windsor! My Dad and his well turned-out friends were able to achieve local sartorial notoriety wearing off-the-peg clothes—like most of us. The key to men's dress is to follow the rules of "F&F"—clothes that Fit and Flatter. An off-the-peg suit that follows your God- given natural lines and flatters your height, your waist, and even posture, can ensure an abundance of spoken and unspoken acclaim from the knowing masses!

So, in this introductory essay on dress: Find a designer—Ralph Lauren, Samuelsohn, Oxxford Clothes, Armani, Hickey-Freeman, etc.—who follows your natural body lines—height, weight, leg length, arm length, etc., in a way that accentuates your God-given geometry. In doing so, as the songwriter Johnny Mercer wrote, "Accentuate the positive and eliminate the negative. . ." Choose colors, discreet ties, and English shoes that reflect your personal taste and style. Follow these simple rules and off-the-peg will equal bespoke in its effect on the waiting public.

Good Luck and Happy Clothes Hunting!

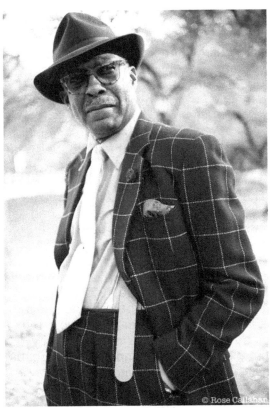

Permission by Rose Callahan

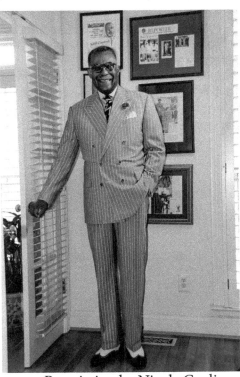

Permission by Nicole Gagliano

TIMELESS CLASSICS

Have you noticed the number of aging rock stars who have discovered The Great American Songbook of Gershwin, Berlin, Ellington, Mercer and Porter? Some notable "vocal" examples who have received their AARP cards in the mail include Rod Stewart, Elton John and most recently, Sir Paul McCartney. Does aging DNA trigger the singer's need to return—like salmon who instinctually swim each year upstream to spawn—to those timeless songs immortalized by the likes of Crosby, Sinatra, Ella, Tormé and Nat Cole? These acknowledged talents recognized, long ago, the value of these songs as musical roads to pop culture permanence. Once they understood their enduring appeal, they never deviated from these musical gems.

Such is the case with men's clothing. The correct cut of a jacket and trouser and their alluring design and effect on the fairer sex was firmly established by the early 1930's. So we must and should return to clothing, particularly suits, that flatter the vertical male silhouette—jackets with drape and that artfully follow the symmetric imperative of the body's proportions. We may occasionally, like an over-excited driver, go "off the road" as we experimented with elephantine- sized lapels and bell bottom trousers in the 1970's and in our current preoccupation with tight uncomfortable suits. The clinging quality of some of the current suit models look like the tight undergarment worn by pro football players, suited more for clandestine night-time military activity than for strolling Fifth Avenue! In due time, our sartorial compass will direct us back to the classics. Those timeless jackets and trousers with character and cut that when seen, bring a sense of joy to the viewing public—not unlike a rousing Sinatra ending to a Cole Porter song!

Sartorial experimentation is expected as a young man seeks to find his own personal style; but never confuse a clothing hyperbole with permanent, tasteful style.

So like Rod Stewart's new Johnny Mercer record, singing the classics can be another means of reinventing your style, but in a winning and appealing manner. So, when in doubt, reach for the classics!

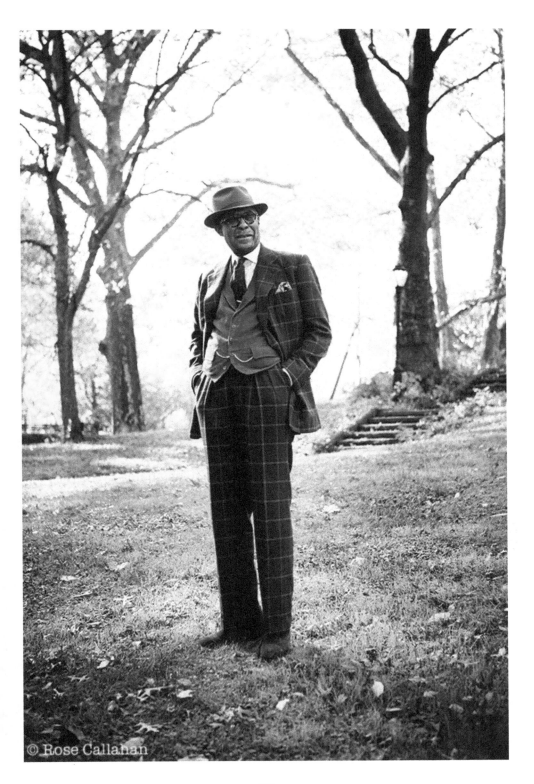

FESTIVE OCCASION DRESS

In more discerning times, when people were asked to "dress for dinner," it meant that you would wear black tie and its accompanying accoutrements. Nowadays, we are lucky if men wear tucked in shirts and not tee shirts to dinner. From Alan Flusser's reference guide for dress, "Dressing the Man," he reviews that formal dress is white tie and tails and semi-formal dress requires black tie and a dinner jacket.

Sadly, with fewer society and opera balls to attend, we have fallen away from wearing white tie. Now "formal-wear," in general, means black tie. In my attempt to not be so rigidly tied to the rules, I guess I can accept this, but please let's do it right! In this festive time of year take an ounce of courage and "dress" for dinner in black tie. I guarantee your wife will be impressed—if not shocked senseless—by your display of "Fred Astaire" style and you might get the best table in the restaurant! So remember: Pair the black tie with a black dinner jacket with matching trousers. And for those who have passed the advanced sartorial training curriculum, consider midnight blue tie with matching jacket and trousers. I favor silk grosgrain facings on the jacket, but satin is fine—grosgrain in midnight blue is harder to find.

Let's now move from classic dress to jazz! Consider the following variations on the common theme: 1) Black silk or cotton velvet shawl or peaked lapel (NEVER NOTCH) dinner jacket with black dress or green tartan (black watch) dress trousers ; 2) Blue or red tartan shawl collar dinner jacket done with midnight blue or winter white dress trousers. It is a festive time; so add a dash of color!

The key with festive dress is to have fun with the rules and be guided, not "ruled," by them!

Enjoy the season and keep those patent leather pumps shined and ready. Who knows, you might be asked to "dress" for dinner!

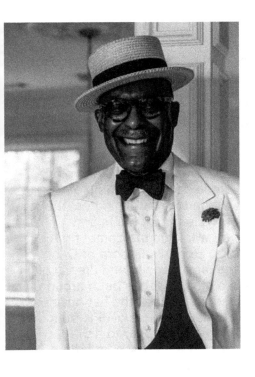

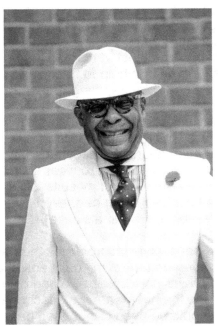

Permission by Nicole Gagliano

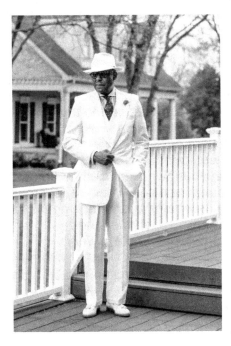

OF HATS & SHOES

The Symphony Ball was this past weekend at the Schermerhorn Symphony Center, our Greco- Roman Temple to Classical Music. The Symphony Ball is one of two annual white-tie balls in Nashville. I would guess that we are one of the few cities left with two white-tie balls a year. This excludes the banal "debutante coming out balls" that occur in most cities.

A white-tie affair is one of those ripe occasions to re-examine men's dress and its rules. The key differences from day dress are "the crowning glories"— the Top Hat and the elegant patent leather dress shoe in its pump or traditional plain cap-toe creations. The top hat derives its origin from the original "English crash helmet" used by aristocrats for fox hunts and steeplechases. Day hats for town and country wear run the gamut from the sporty porkpie— favored by Fred Astaire to Bogart's Fedora or Dean Acheson's sober and somber Homburg— the most serious and dressy of our traditional day or evening hats. There is a story that has been around for years, that the hatless John F. Kennedy personally closed the hat business. This is only partially correct. If you carefully review pictures of JFK from day one of his presidency, you will see him wearing a silk topper to his inauguration and occasionally carrying or wearing a narrow brim fedora. Personally, I think JFK knew that his hair was a key part of his image and charisma, and elected to not hide it under some prosaic hat. Please note, that if any one person helped to diminish the dress hat the most, it would have to be Mr. Frank Sinatra, the greatest entertainer of the 20th century. Sinatra's swinging 1950s style was partly derived from his jauntily angled fedora. He and his hat adorned album covers and in many of his 1950s TV specials, you see "The Chairman of the Board," wearing his trademark fedora or Cavanaugh hat (straw/coconut hat with a wide white linen band). So to be "Sinatra cool," you had to wear such a hat; and legions of fans did. Enter the 1960s with the skinny suits, skinny ties, narrow trousers and the classic men's hat slowly morphed, even on "Ole Blue Eyes," into a baseball cap (Dodger blue in Sinatra's case!).

My personal style incorporates the hat in its many incarnations: It serves as "the cherry on top" of my daily ensembles. It just feels right. I suspect "the feeling right" part is helped along by the diminishing hair on the top of my skull and the hat's warming effect on my cold cranium! Hats, like suits and ties, should be used or not used based on your personal style choices; but please don't avoid them out of fear. If you wear a hat, wear it like you own it, not like it owns you! Being comfortable in your own skin, clothes and hat is a cultivated sensibility; so start studying and sizing-up which style, crown height, and brim width fits your geometric proportions best. Once again, the rules of balance and symmetry define what hat size, shape, and measurements are best-suited for your head. For example, a very wide-brimmed hat on a really skinny guy makes him look slimmer and more like a Jerry Lewis movie character. In addition, a hat with a narrow brim and a very short crown on a big man with a large neck and chest also promotes a comical appearance. There are "hat doctors" in many cities—hat shops with

hatters or salesmen who understand "Hat Style and Geometry 101." These knowing folk will keep you off the local cartoon pages.

Moving to shoes, I mentioned that a really serious shoe should adorn the feet of a man wearing what amounts to the most dressed up suit you will ever wear—tails with white tie and accessories. In the case of the white tie outfit, an unadorned black cap-toe—either patent leather or regular black leather—will suffice. So a cap-toe with medallions and perforations is not suited for evening business wear or even semi-formal dress—for example, an evening marriage. The classic wingtip with its brogueing is best suited for daytime suitings and country wear. It is a less formal shoe—as is the loafer and brown suede shoe of any shoe style (e.g., cap-toe, wingtip or loafer). To be more explicit, Fred Astaire, The Duke of Windsor, and their stylish friends elevated wearing the single-piece Oxford tobacco or honey-colored suede lace- up to a level of high art—but please note, never in black! Astaire would wear the brown suede with all suitings and country wear (tweed jackets and flannel trousers). It takes some dressing gravitas and sophistication to pull this one off! But with practice and studied nonchalance, it can be done!

Lastly, we are moving into the realm of sophisticated dressing when I review the proper attire and occasion for crocodile tassel loafers, Belgian slippers, and black velvet tasseled loafers. We will delve into these deeper waters in next year's "post-graduate course."

In the meantime, Dress Well!

Permission by Rose Callahan

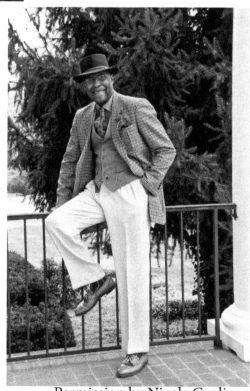

Permission by Nicole Gagliano

ON WHITE TIE AND TAILS

"White tie only" on an invitation is a rarity now, only seen at the occasional diplomat ball or in Nashville at The Swan Ball. For time travelers, the early 1960s was when attending a formal event designated by the woman wearing a long gown, required the man to wear white tie dress. Think of the JFK inauguration and then fast forward to Gerald Ford and beyond. Oddly, even Nixon hosted a few white tie events; there is a photo of Fred Astaire dancing with entranced female guests at a White House event that comes to mind. In its heyday, the regal 1930s, when all the major rules on men's dress were firmly nailed down and the dress styles had evolved to their zenith, "black tie" equaled semi-formal and "white tie" was the true formal dress. So, what happened? I am not sure; but I *am sure* G. Bruce Boyer would know!

It likely became more convenient to wear black tie since not everyone had a tailcoat and all the components of "white tie" ensemble. It is also likely that some swells began the custom of wearing black tie to the formal events and it just evolved. For example, if you follow the pattern of men's dress for the televised Academy Awards event from the late 1950s to the present, you will see the evolution from white tie to black tie play out on the small screen. By the mid-to-late 1960s, one would see a smattering of full dress ensembles (the formal name for "white tie") and a majority of black tie ensembles.

But back to the original comment. Full dress ensembles are as dressed up as a guy can get. The architectural lynch pins of this ensemble are tied to 3 key elements:
1. A very high wing collar shirt that creates at least 2-4 inches of separation from the jacket collar to the top of the shirt collar. This creates a formal air—look at when wing collars or their ancestors were worn by the likes of Beau Brummell, there was always a sizable jacket to shirt collar gap. The sight of a wing collar being swallowed up by the coat collar creates a sloppy visual effect.
2. The points of the waistcoat front (please pique cotton—not satin and not wool) should be less than the opposing points of the tailcoat. The white color peeking below the tailcoat front is an effrontery to stylish dress. One gets sartorial demerits on this one. This will require a LONG RISE in your trousers, and force you to wear your trousers where they should have been in the first place—on your natural waist or some place near or close to your navel.
3. The tails of the tailcoat should end at the middle of your knees. For short guys, such as the iconic Mr. Astaire--who was about 5'6", he cut them a little short (check out "Top Hat," 1935) to create the visual sense of added vertical height.
4. The crowning glory is the top hat or its collapsible cousin, the Opera Hat or *Gibus*. Its original role was as a crash helmet for the British nobility as they jumped bushes and fences on their way to capture, hopefully, a very sly red fox.

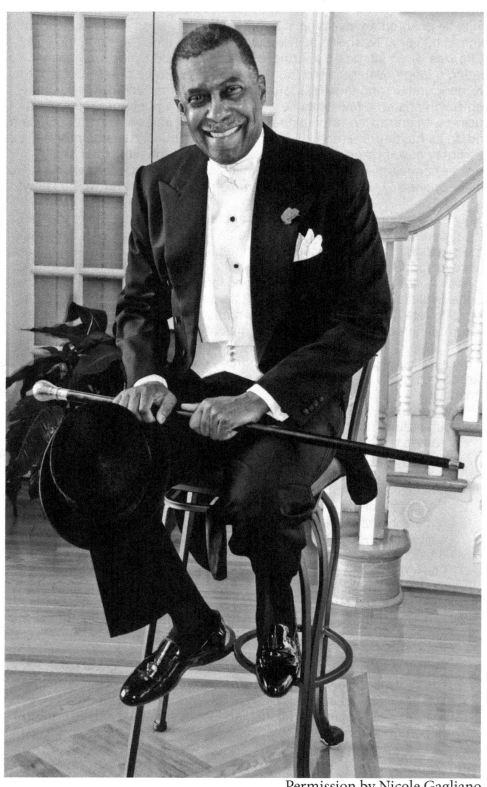

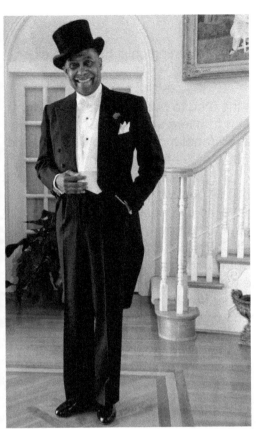

Permission by Nicole Gagliano

THE START OF FLANNEL SEASON!

We are on the verge of autumn: a time of early morning chill, hot apple cider, and college football.

Along with these seasonal events comes the time to put away the lightweight worsted suits, cotton seersuckers, and linen trousers and bring forth the flannels! To those students of men's dress, flannel more than any other fabric has been the defining textile of modern men's dress from 1920 to the present. Flannel comes in many weights, but the heavy stuff—12 ounces or more in weight—has character and depth. The breadth of colors from dove grey (very-light colored—the wings of a dove) to charcoal (nearly but not exactly black) offered the dressers of the past and now the present a wide variety of colors from which to create a fall wardrobe. Fred Astaire loved the fabric. He can be seen wearing flannel year round (recognize he lived most of his adult life in southern California). He would pair flannel trousers with the odd tweed or plaid jacket and his omnipresent brown, single-piece suede oxford shoes. He also wore dove grey, pearl grey, and flannel chalk-striped suits on the screen and in his regular dress. In recognition of his fondness for all clothing flannel, Audrey Hepburn, his co-star in the movie "Funny Face," gave him a picture framed in grey flannel!

Dressers know that fall offers them the opportunity to add to their tweed jacket collection and to wear their beloved all-purpose grey flannel trousers! Robert Gillotte, the director of custom shirts at Turnbull & Asser's New York store, and the best-dressed man in NYC, lives for flannel weather!

Due to modern textile engineering, one can get true summer flannel trousers in 9-10 ounce weights which will reduce the constant search and need for air conditioning!

Full service men's stores recognize the value of grey flannel trousers and will include a significant supply for their fall trunk or apparel lines.

Wear your grey flannel suits and trousers as a sign of sartorial sophistication! You will join a long line of dressers from Fred Astaire, Douglas Fairbanks, Jr. and Sr., Gary Cooper and a host of notably decked out swells. Don't forget your cashmere or wool challis ties, brown suede shoes, and spread collar blue broadcloth shirts. In doing so, you will warm the hearts of your significant other!

In summary, brush off those tobacco brown suedes, press those flannel trousers, clear the art deco tile floor, and get ready to dance into autumn like Freddie Astaire!

83

LATE WINTER & EARLY SPRING MUSINGS

A successful life lived mostly sane, requires periods of rejuvenation and inspiration. I view my clothes and my involvement in their design and creation as such moments. As I studied my father, for nearly 56 years, I learned many lessons. One is that the careful choice of clothes and the personal style one develops living in them can again serve both necessary needs of rejuvenation and inspiration. The psychic weight of daily living can dull one's senses and filter out moments of joy that by serendipity come your way. So one must continue to hone your skills and senses to grasp brief respites that are joyful and stir your sartorial creativity.

The yearly budding of tulips and dogwoods in the spring of my native South, stir my sartorial needs for suits constructed from Irish (not Italian) linen, fresco cloth and Dupioni silk. Like the Italians of any age and the American tycoons of the 1930's, I favor uplifting vivid colors. Such spring hues elevate your mood and adds your meager visual contribution to God's bright floral displays.

Thank goodness, we are soon to feel the last biting touch of winter and the onset of the healing warmth of spring's soothing breezes. Why not join in Nature's symphony with white leather wingtips, cream-colored double-breasted suits, and open collar linen shirts—with the ensemble completed with an ascot or bright floral scarf!

In recent years, men's dress has been a bit too constrained and conscripted—as in the details of a doctor's prescription to follow without question. I suggest, dressing for comfort and above all for your inner self. For you see, my father, rest his soul, had found one of the secrets of life—dress for no person but for yourself.

Permission by Barry Noland

Permission by Rose Callahan

SPRING IS TRULY HERE

I am a huge fan of the music of Richard Rodgers and Lorenz (Larry) Hart. Their music is over seventy years old and remains as fresh and modern as if it were written today. There is a tinge of melancholy in most of their songs, the origin of which, is traced to the angst-ridden life of Larry Hart, who, during his short, substantive career, kept his sexual preference for men hidden. One of their songs, "Spring is Here," is a fabulous ode to Spring. Its message of bittersweet love, still serves as a contrasting anthem to the bright, sunny, cool days of spring. Spring is a season of hope and life renewed with all its unexpected possibilities. Furthermore, the bright palette of spring offers us a chance to be a walking symphony of bright buoyant moods, smiles and joys. So, wear a French blue nautical blazer, not one of dark navy; wear cream yellow suits, not somber neutral browns; and white linen and cotton shirts that compete with the heavenly clouds of spring.

The Italians and notable American dandies understand how dress is connected to their souls and personalities. Open yourself up to the possibilities of cutaway and spread collar dress shirts; dress shirts of vibrant stripes; suits of fresco cloth, Irish linen and brushed cotton. Look for new possibilities, outside the perfunctory banal worsted navy and grey suitings.

Expanding your clothing color wheel will open your life to other creative possibilities stimulated by your sartorial thinking. You may see your colleagues' odd eccentric ideas as new possibilities!

With such mind-expanding possibilities "literally afoot"—brown and white spectators and classic cut Oxfords made of brown leather with linen—your daily grind will take on another life. Your work will be a period of self-expression in dress, and hopefully in thought, that will dazzle your clients, colleagues and all that witness the "new you!"

Remember, "Spring is Here" and you will finally know "Why Your Heart is Dancing!"

Permission by Nicole Gagliano

THE IMPERATIVE OF COLORED SUMMER CLOTHING

Tom Wolfe understands.

Certainly, better than most. A white—not cream-colored—suit grabs the attention of the passing crowd. He strides like a man brimming with sartorial courage into the mad Manhattan masses and dares anyone to question the imperative of his white suit. Now, I think that colored summer clothing, white included, offers a man a chance to express inner joy and sartorial flair. For you see, the origin of expressive 20th century men's suiting colors were the result of European style experts defining appropriate seasonal colors. This lead to the use of pale yellow, light blue, French blue, ivory, white, cream, dove gray and a host of other colors in men's clothing and particularly in suits. Most of this work occurred in the 1930s. From these efforts, the properly- dressed man would wear pale yellow two-piece suits, double-breasted cream suits with patch pockets, powder blue two-piece suits or powder blue sport jackets with navy, dove gray flannel or cricket cloth white trousers—full cut, of course. None of those straight-jacketed tight clothes for these boys.

As you seek to be more self-expressive in your "modern" male dress, harken back to the days of ubiquitous light-colored clothing. It will offer you a wider palette of choices when it comes to suits and jackets. Also, wearing blue and gray all the time does get a bit boring

Don't forget the light blue seersucker suitings. Don't stop there! Be Gatsby-esque! Be bold! Try a pink, double-breasted seersucker number. It will, as Mr. Fred Astaire said, "Knock them in the aisles!"

In closing, let's spend a little time on fabrics that men typically neglect—linen and cotton. These fabrics are highly-suited, due to their porosity, for the humid and hot weather of summer. The knowing dressers understand the style and beauty of wrinkled cloth. The great dressers recognize that wrinkles in the fabric bring gravitas. Remember Hercule Poirot and the Duke of Windsor—eternally stylish and exquisitely wrinkled.

Remember, distinction and grace in one's attire is expressed in subtle ageless ways.

Permission by Rose Callahan

FALL COLORS

I know that it is the time to pull my fall clothes out of storage when the fall Paul Stuart catalog lands in my mailbox.

There were a few years when many of us who write about and study classic men's dress were concerned that our ship had sailed and we were faced with permanent trendy evanescent fashion waves in men's dress. Nothing was sustainable or connected to the well delineated rules of dress. Thank goodness, the last few years have revealed a virtual explosion of internet blogs that celebrate classic men's dress and a new, beautifully-crafted magazine, The Rake, that offers sartorial sustenance for the "clothing hungry" aficionados.

As we enter the early weeks of fall, many of us revel in the celebration of the vibrant hues of the season. The bright colors of autumn seem to bring us out of our summer sartorial hibernation. Hindered by the steamy hot days of summer, the chilling breezes of fall have made possible the wearing of flannel suits, flannel trousers, suede shoes, flannel dress shirts, Chukka boots, and Polo top coats. The weightier fabrics of fall, cause suits and trousers to drape over the vertical male silhouette in a more flattering manner. Jackets with darts follow the natural curves and angles of the torso—which focuses the female eyes to this very male adornment.

I would offer a challenge to male dressers to embrace the colors and clothes of autumn: burnished red tassel loafers, deep brown tweed hacking jackets, golden-brown solid cashmere ties, hunter green tweed country suits, winter white jackets and trousers, and deep navy blue 14 ounce suits to die for.

Learn how to use complementary colors to organize and bring harmony to your outfits—suits, jackets and odd trousers. Recognize the value of a solid black silk knit tie and ties of flannel and cashmere. Seek out and find cavalry twill trousers that elevate the classic solid tweed sport coat to a level of sublime sophistication.

Let us not forget about the eye enhancing feature of pale or solid cream cotton or cashmere over-the-calf socks.

Fall is a special time for many activities: college football, tailgating before the big game, the bright golden foliage that will replace the green leaves of summer, and lastly, the myriad number of sartorial ensembles that autumn offers us.

We need only the courage of our convictions to wear the bright, rich, enhancing colors of autumn.

Come on in; the water's fine!

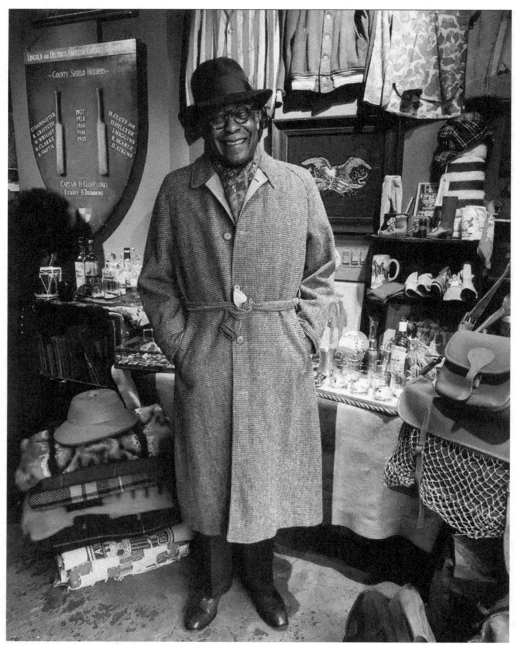

Permission by Sean Crowley

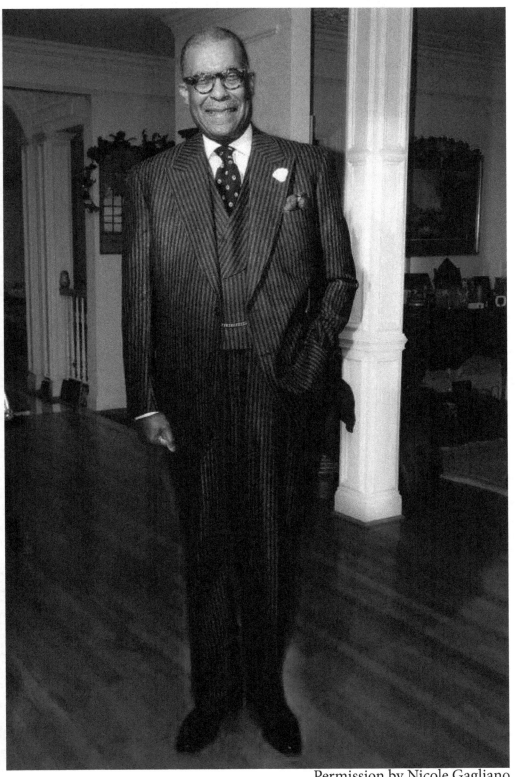

References for *Sartorial Matters*:

- Boyer, G. Bruce. "Elegance: A Guide to Quality in Menswear," New York: W.W. Norton & Company, 1985.
- Boyer, G. Bruce. "Eminently Suitable," New York: W.W. Norton & Company, 1990.
- Flusser, Alan. "Dressing the Man: Mastering the Art of Permanent Fashion," New York: Harper Collins Publishing, 2002.
- Schoeffler, O.E.; Gale, William. "Esquire's Encyclopedia of 20th Century Men's Fashions," New York: McGraw-Hill, 1973.

DRAWINGS

DRAWINGS

I have sketched since I was six years old and find that it offers me a venue away from my day job as a cardiologist and medical administrator. In recent years, I have realized that drawing presents me unique and unexpected insights and solutions to challenges posed by my daytime jobs. Clinical psychologists have informed us that drawing creates cerebral hemispheric connections and neural activation that allows incubation on a host of problems that you are trying to solve.

On the next pages, you will bear witness to what happens to an illustrator when he lets his thoughts wander and he draws whatever comes to mind—both the serious and the absurd.

97

INDIAN FIGHTER

BALE

8/21/2014

BACK VIEW OF MICHELANGELO'S DAVID

TO Raymond,

From a lucky curtor, Andy

5/8/2014

LANCE THROWER
BY ALL W18

12-22-2017

Studies

ARM /
HAND

From
Michelangelo

By All
2018

HAND

HORSE.
1540

AFTER
MICHELANGELO
Ace
11-1-2015

111

1534. AFTER
MICHELANGELO
11-1-2015

LAMP POST

AFTER
MICHELANGELO

B. Ale

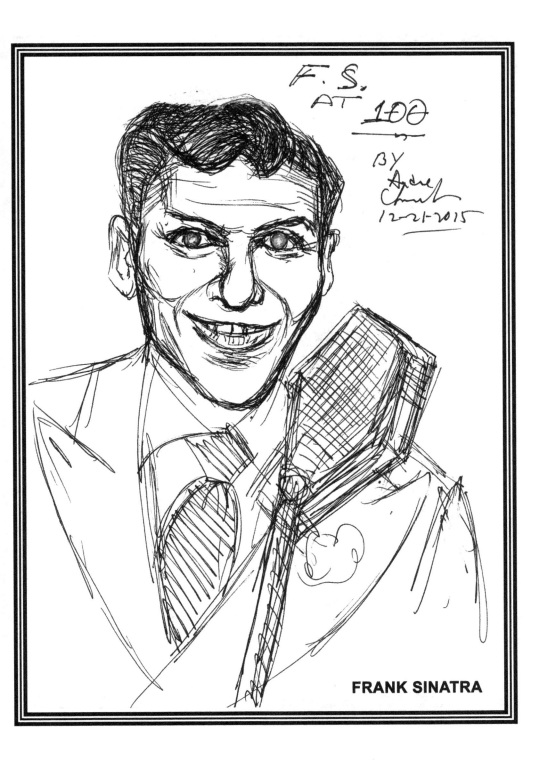

F. S.
AT 100

BY
Andre
Chur
12-21-2015

FRANK SINATRA

CHET B.

SING AND FEEL IT...

119

121

BY
André Z.
Churchwell
9/27/2014

THE ACROBATS

124

HANDS

BYRNE
2005

BY Arc

131

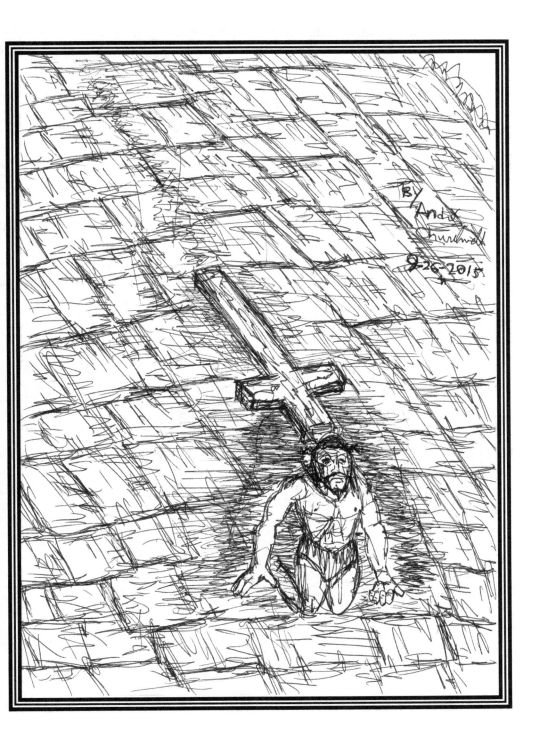

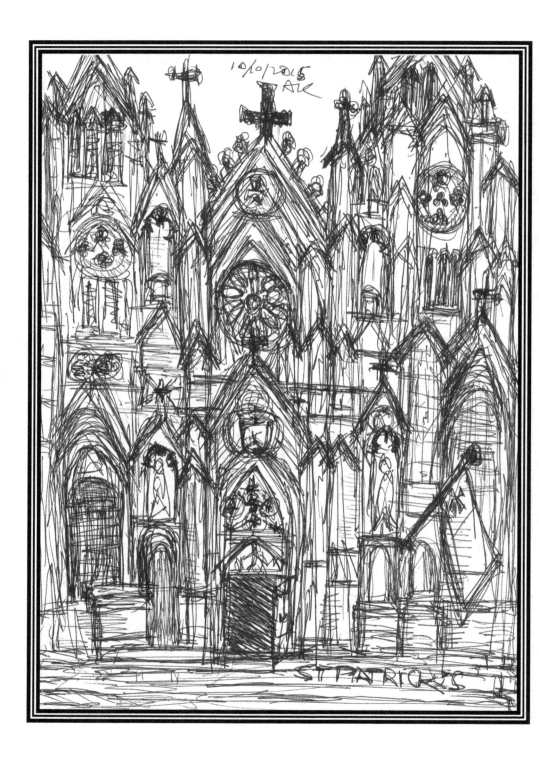

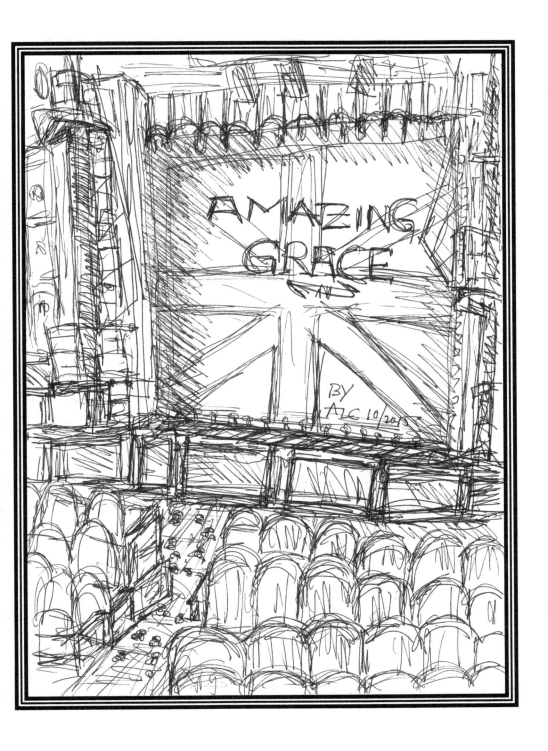

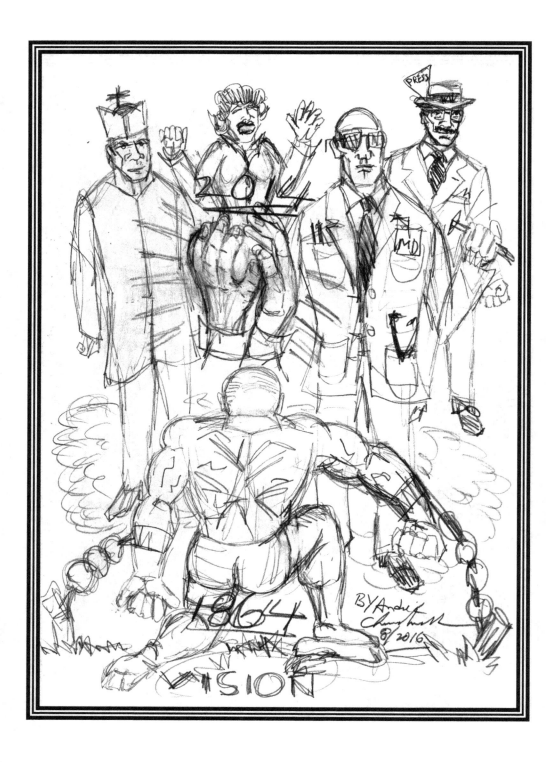

FACES

152

MULTI-
CULTURAL
US.

BY AU
2017

153

BYAM
2017

AFTER
SARGENT

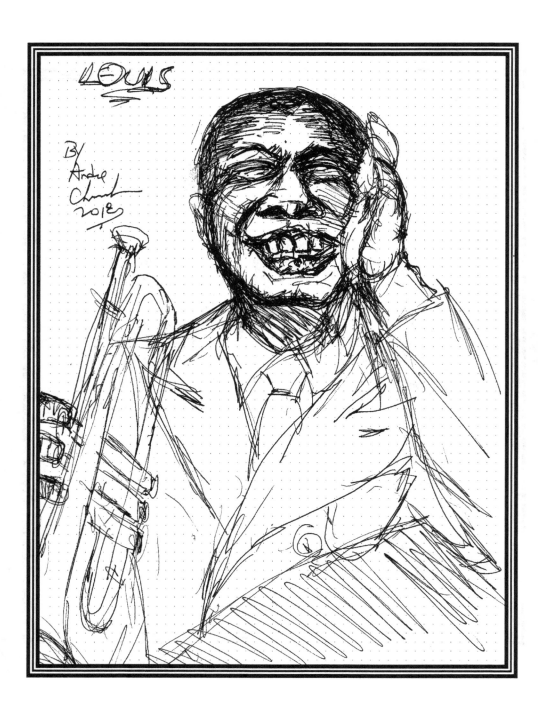

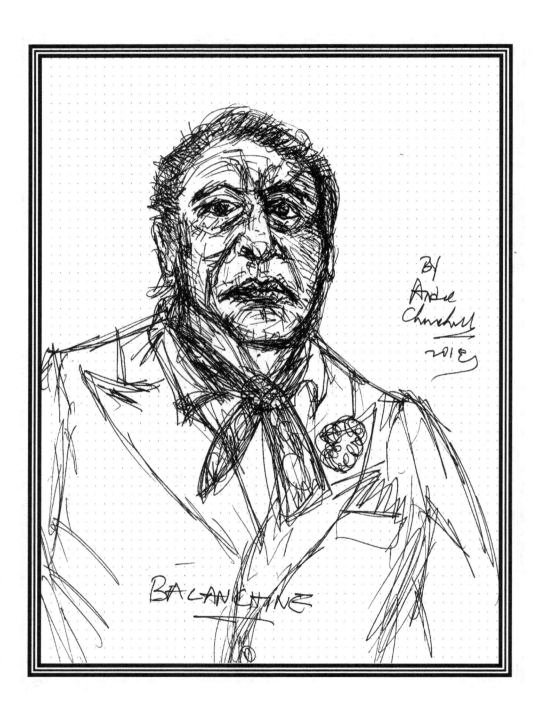

BALANCHINE

By
Andre
Churchill
2019

AGNELLI

BY Andy 2018
Chillon

FACES IN ROMA!

VARIATL

6/3/2013

162

FROM CAFÉ

JUNE 5
Wed
9:00 Am
13' kfast

CONSTANTINE 315 A.D
ARCH OF
TRIUMPH
6/5/2013

6/6/2013 BY Andre Churchwell

ROME SERIES

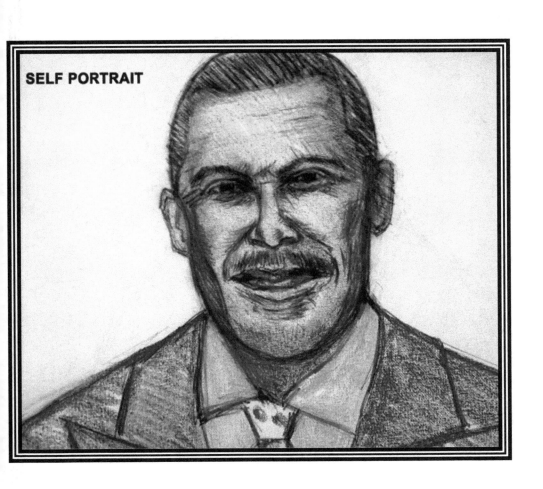

SELF PORTRAIT

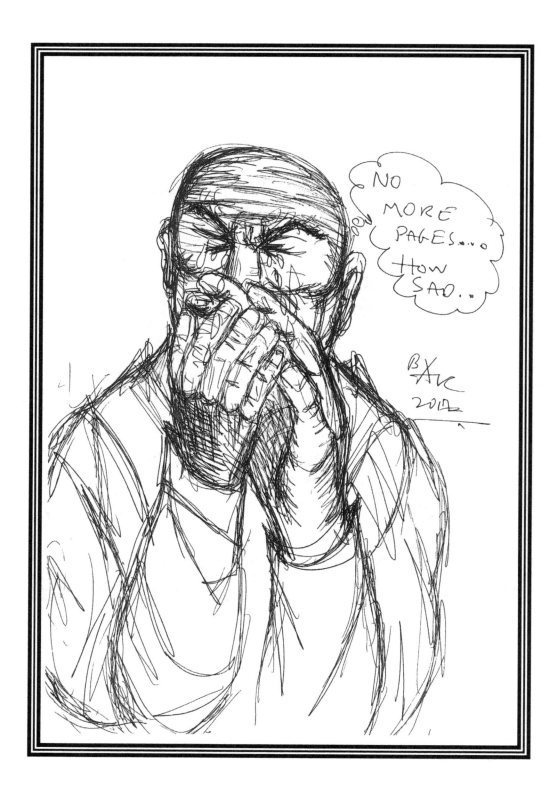

CPSIA information can be obtained
at www.ICGtesting.com
Printed in the USA
LVHW081430161022
730827LV00003B/12